VICTORIA

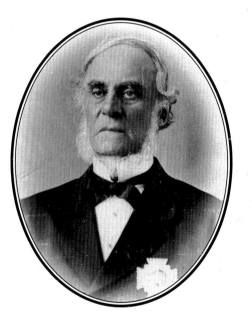

··· A HISTORY IN PHOTOGRAPHS ···

VICTORIA

Peter Grant

VICTORIA | VANCOUVER | CALGARY

Heritage House Publishing Company Ltd.
www.heritagehouse.ca

LIBRARY AND ARCHIVES CANADA CATALOGUING IN PUBLICATION

Grant, Peter, 1948–
 Victoria: a history in photographs / Peter Grant. —1st Heritage House ed.

ISBN 978-1-926613-33-8

 1. Victoria (B.C.)—History. 2. Victoria (B.C.)—Pictorial works. I. Title.

FC3846.4.G72 2010 917.11'28 C2010-900476-0

Edited by Yvonne Van Ruskenveld
Cover design by Jacqui Thomas
Interior design by Stephen Hutchings
Layout by Nancy Green and Sandra Davis

FRONT COVER: The Black Ball ferry *Chippawa* entering Victoria Harbour, with the newly built Empress Hotel in the background. Detail of City of Victoria Archives M06999.

PAGE 1: Sir James Douglas is recognized as the founder of both Victoria and British Columbia. Born of mixed race about 1903 in the West Indies, Douglas learned the fur trade and became a chief factor with the Hudson's Bay Company. He established the site of Fort Victoria and supervised its construction. Douglas returned with his family in 1849, when the company was chartered to establish a colony on Vancouver Island. He was both governor and senior company officer, and later governor of both Vancouver Island and British Columbia. Douglas lived in Victoria until his death in 1877.

FRONTISPIECE: House posts at Songhees Village, believed to be the house posts of the second chief of the Songhees Band. These posts were purchased by the American Museum of Natural History in New York.

OPPOSITE: The Imperial Oil tower and service station, built on Victoria's Inner Harbour, opposite the Empress Hotel in 1931. A revolving 10-million-candlepower beacon sat atop the art deco tower. Visible for 100 kilometres, it was intended to guide seaplanes into the harbour.

BACK COVER: Postcard of cyclist on Government Street *circa* 1910, courtesy of John and Glenda Cheramy.

Printed in Canada

This book has been printed with FSC-certified, acid-free papers, processed chlorine free and printed with vegetable based inks.

Heritage House acknowledges the financial support for its publishing program from the Government of Canada through the Canada Book Fund (CBF), Canada Council for the Arts and the province of British Columbia through the British Columbia Arts Council and the Book Publishing Tax Credit.

Canadian Heritage Patrimoine canadien

The Canada Council | Le Conseil des Arts
for the Arts | du Canada

BRITISH COLUMBIA
ARTS COUNCIL

15 14 13 12 2 3 4 5

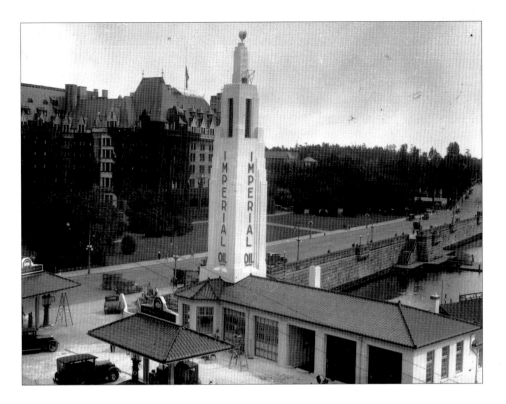

Contents

The Fort

"The place itself appears a perfect Eden," enthused James Douglas about the southeastern tip of Vancouver Island—the setting of a Hudson's Bay Company (HBC) trading depot established in 1843. Named for the young British queen, Fort Victoria provided a tidewater base for the company's burgeoning maritime trade. It also solidified the British claim to possession of western North America that explorer George Vancouver had staked in 1792. American settlers in Oregon Country urged annexation of all territories south of Alaska, but isolated posts like Fort Victoria proved enough of a foot in the door to make the British claim stick. By a US-British treaty signed in 1846, Vancouver Island and all the western continent north of the 49th parallel outside Alaska became British.

For perhaps 2000 years, Coast Salish nations have inhabited southeastern Vancouver Island, as well as the mainland coast from the head of Puget Sound as far north as Bute Inlet. There were more than a dozen Salish winter villages on beachfront sites within 20 kilometres of Fort Victoria. Two days after Douglas hired a Salish workforce to procure pickets for the fort's stockade, Father Bolduc said mass before 1200 Native people. Soon a Salish trading village grew up near the fort. There was constant friction, between the HBC employees and the Natives, and even occasional attacks on the fort. But the Scots and French Canadians of the HBC endured—supported by Royal Navy gunboats.

Fort Victoria became the nucleus of the tiny British colony of Vancouver Island established in 1849. The British government leased Vancouver Island (area 32,000 square kilometres) to the HBC for the nominal annual rent of seven shillings on condition that the company establish settlements within five years. By 1858, the colony's European population was little more than 500. Songhees Village had a permanent winter population of about 700.

The Fraser River Gold Rush of 1858 rescued the struggling colony. As many as 30,000 miners sailed from San Francisco to Victoria to purchase mining licences before setting out for the gold fields. Those who stayed included hostellers, merchants, prostitutes, and even a few nuns from Quebec.

The establishment of the Crown Colony of British Columbia in 1858 brought a huge area under Victoria's control. James Douglas resigned his position with the HBC to be the governor of both colonies. Douglas made certain that Victoria would be the centre of supply for this vast hinterland by declaring it a free port. Less than 20 years after its founding, the settlement graduated to the status of a city.

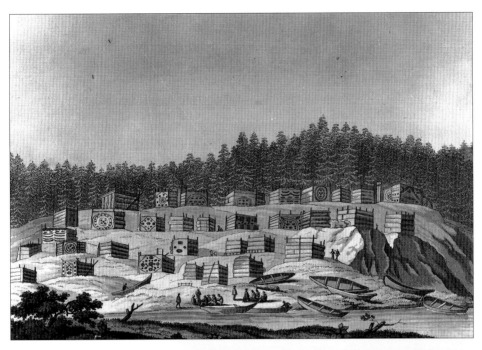

Above: *"Cheslakee's Village on Johnstone Straits."* George Vancouver encountered this Kwakwaka'wakw' village while navigating the hazardous waters off northeastern Vancouver Island in 1792. Spanish parties explored the coastline around Victoria in 1790 and 1791 but left no images of the place or its inhabitants.

Right: *Alexandrina Victoria (1819-1901) took the throne of Great Britain and Ireland in 1837. At 21 Victoria married her cousin, Prince Albert of Saxe-Coburg-Gotha.*

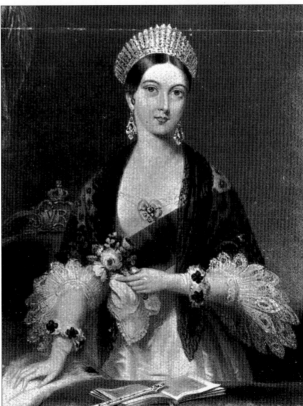

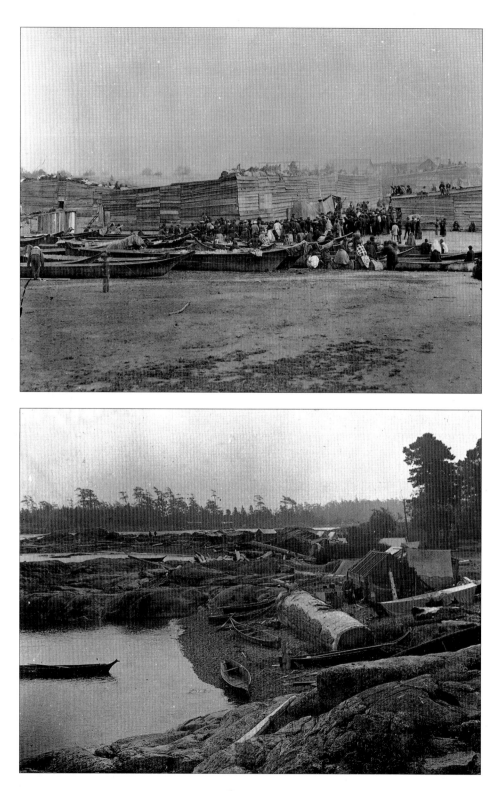

Opposite top: *Songhees village became the principal settlement of the area's inhabitants after the establishment of Fort Victoria. Between 1850 and 1852, they abandoned their winter villages and sold most of their lands to the Crown, for reasons that are unclear. Richard Maynard photographed the village, with its big houses clad in cedar planks, during a potlatch ceremony in 1872.*

Opposite bottom: *Skingeenis Village on Discovery Island, east of Oak Bay. It was abandoned after Fort Victoria and Songhees Village were established but reoccupied during the smallpox epidemic of 1862. People continued to live on the picturesque group of islands well into this century.*

Above: *An early photo by Frederick Dally, one of Victoria's first photographers. The Songish or Songhees people were really an amalgamation of several autonomous bands. The name was that of a band that occupied present-day Metchosin.*

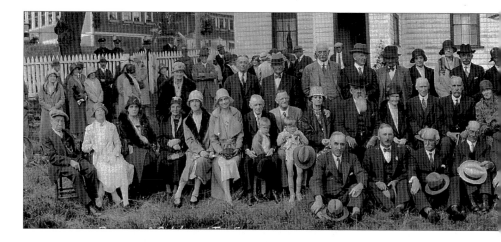

Dr. Helmcken Remembers

JOHN SEBASTIAN Helmcken M.D. (1824-1920) arrived at Fort Victoria in 1850. He married James Douglas's daughter Cecilia, 17, and built (1852) a log house next door to his in-laws. The Speaker of three colonial legislatures, Dr. Helmcken later recalled the first "parliament" of 1856.

"Before the end of July all the elections had been held and the 'House' was called to meet for the dispatch of business about the middle of August....Behold the seven honourable members seated in the 'House of Assembly' this being 'Batchelors' Hall,' a part of the squared log building situated in the 'Fort,' about the spot where the Bank of British Columbia now stands. The 'House of Assembly' Hall was a room therein about twenty feet in length by about a dozen in breadth, lined with upright plank unpainted, unadorned, save perhaps with a few 'cedar mats' to cover fissures....In the centre stood a large dilapidated rectangular stove.... Imagine, then, half a dozen honest, upright, intelligent, well informed, well mannered gentlemen, meeting to discuss any unimportant or important question, whether in the House or out of it, and you will form a very good idea of the debates in the House of Assembly. Of course there were disagreements, but assuredly these people had honest conviction, a conviction however often governed in one or two by personal hatred to the Governor, the Hudson's Bay Co., fur traders, 'et hoc genus omne.' Such as is human nature is, so were these. One thing is certain, they did not speak 'to the galleries,' for no audience attended; not for the press, for newspapers and reporter existed not; they did their best for the country, according to their lights."

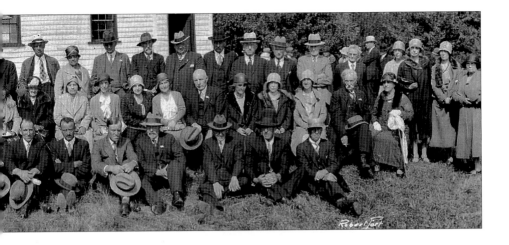

Above left and right: *Former students of Craigflower School gather for the dedication of the 1855 schoolhouse as a museum in 1931. The second school established in the province, it was built by the staff of Craigflower Farm. More than 60 English and Scottish farm workers signed indentures with the HBC and made the voyage around Cape Horn believing they would occupy an already-established farm. They arrived at Fort Victoria in January 1853 to discover they had to*

spend the winter in the fort and then build the farm. (The second Craigflower School, built in 1911 and visible in the left background, has been demolished.)

Above: *Josette Work and two of her eleven children. A*

Spokane Métise, she and HBC Chief Factor John Work married in 1826 "in the custom of the country" (according to Native customs) and lived together for 25 years. They married in the Anglican Church in 1849 to enable their daughters to join Victoria society. Suzette, at left, married E.G. Prior, later premier and lieutenant-governor of British Columbia. The family established Hillside Farm in 1852.

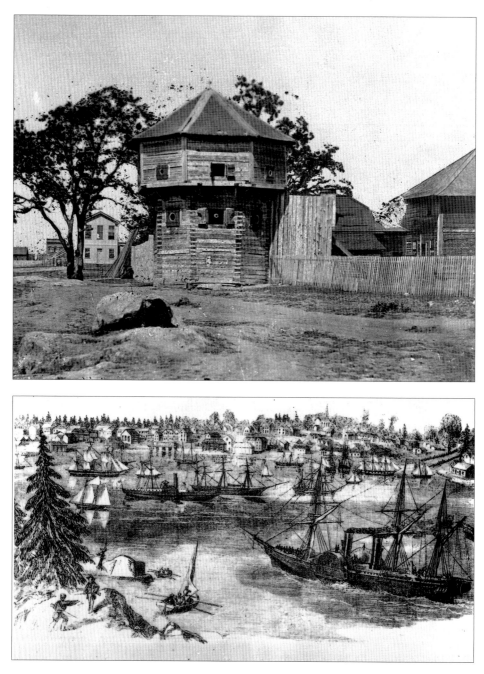

Above: *Fort Victoria's south-western bastion. The fort was torn down to make way for commercial buildings.*

Below: *SS Commodore entering Victoria Harbour from San Francisco in 1858. The tents of transient gold miners are visible between the wooden buildings thrown up in the wake of the Fraser River Gold Rush.*

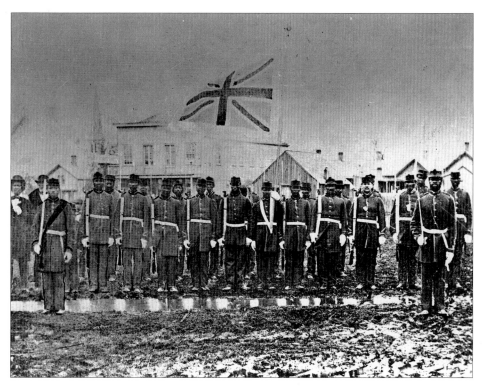

Above: *The Victoria Pioneer Rifle Corps, first militia in the colony of Vancouver Island, established in 1860. Victoria attracted African-American settlers from California, where discrimination had been increasing. While Victoria offered them a freer society, racial prejudice existed here as well. By 1864, the senior company was denied the right to march at state ceremonies.*

Right: *Mifflin Gibbs, a native of Philadelphia, immigrated to Victoria from California in 1858 and established a retail grocery and provisioning partnership. He settled on a five-acre estate in James Bay and became a city councillor. Many African-American pioneer left Victoria by 1870. Gibbs moved to Salt Spring Island.*

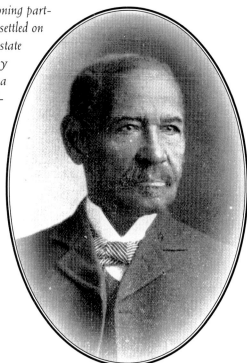

Amor De Cosmos

JOURNALIST AND political crusader Amor De Cosmos (1825-1897) was a native of Nova Scotia, born William Alexander Smith. He changed his name in 1854 while living in California. He explained that the name meant "love of order, beauty, the world, the universe." When he moved to Victoria in 1858, he established Victoria's first independent newspaper, *The British Colonist*, and was its publisher and editor for five years. An unstinting critic of governor James Douglas's dual authority, autocratic style, and generous patronage, De Cosmos championed "responsible" government—"a system long established in British America, by which the people will have the whole and sole control over the local affairs of the colony."

Elected to the colonial assembly in 1863, De Cosmos tried to have the proportion of elected members in the governor's council increased. His consuming passion became the union of the British North American colonies, starting with Vancouver Island and

British Columbia. Union was necessary, he argued, for the colonies' economic prosperity— even their survival, given the threat of absorption by the United States. After 1867, De Cosmos worked tirelessly to drum up support for the inclusion of British Columbia in Confederation. The Terms of Union signed by the colony and the federal government in 1871 were remarkably similar to his proposals.

De Cosmos stood for office in both federal and provincial elections at the same time and was successful. (The practice was soon disallowed.) A year later he was made premier of British Columbia. Ever the politician, De Cosmos diligently pursued the promised

beginning of the transcontinental railroad, a drydock in Esquimalt, and federal assumption of the province's debts. He cut some deals that were at odds with the letter of the Terms, and his compromises became a lightning rod for Victorians' frustrations.

On February 7, 1874, an angry mob spilled out of a public meeting, marched across the James Bay Bridge and advanced on the Birdcages, singing "We'll hang old De Cosmos on a sour apple tree." Into the Assembly room they surged. De Cosmos fled to the Speaker's office. Four days later, he resigned as premier and Member of the Legislative Assembly. In Ottawa, he continued to stand up for BC's end of the Confederation deal. In 1882, however, Victoria's pro-British electorate turned against him for daring to suggest that Canada negotiate her own treaties, and De Cosmos was thrown out of office. After that, Amor De Cosmos became increasingly eccentric, eventually descending into madness.

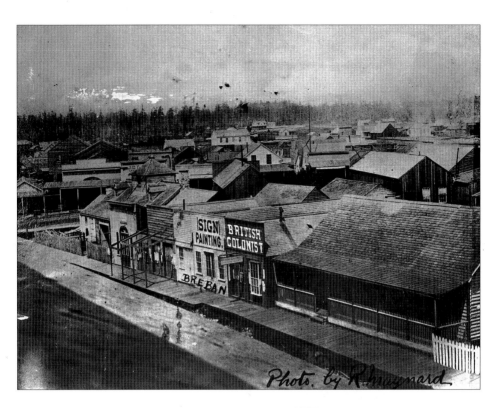

Photo. by R. Maynard

Above: *Amor De Cosmos's British Colonist office on Wharf Street, south of Yates, about 1859.*

Right: *The Birdcages, the colonial government buildings, constructed after the British Government assumed direct control of Vancouver Island in 1859. Five wood-frame buildings, faced with brick and timber housed, from left to right, the land office, the legislative council, the colonial offices, the Supreme Court and the treasury. When the colonies of Vancouver Island and*

British Columbia were united in 1866, a political battle erupted between island and mainland interests over the site of the capital. Victoria prevailed in 1868. After

British Columbia joined Canada in 1871, the buildings served as the seat of the provincial government for more than 20 years.

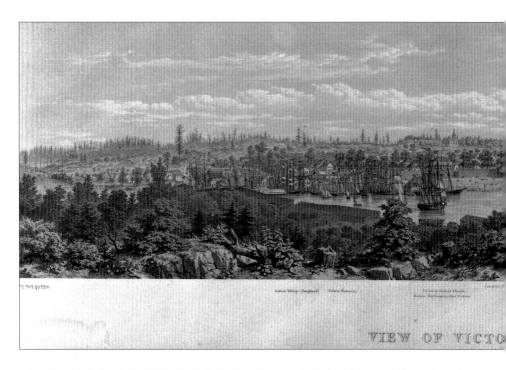

To THE QUEEN

Indian Village (Songhees) Police Barracks Victoria Harbour Church London
Hudson Bay Company's Fort Victoria

VIEW OF VICTO

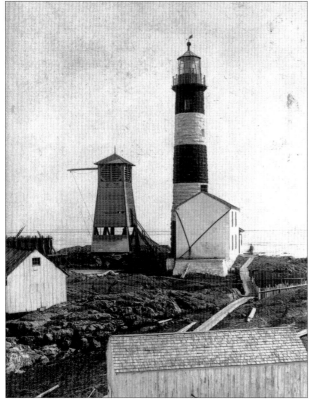

Above left and right: *Panorama of Victoria Harbour in 1860, the year Governor Douglas declared Victoria a free port. Painting by Hermann O. Tiedemann, who also designed the Birdcages.*

Left: *Race Rocks Light Station, built on a treacherous reef near Sooke in 1860 and operating continuously since. Completed a few days after the Fisgard Island light station, it is the second oldest on the coast of British Columbia.*

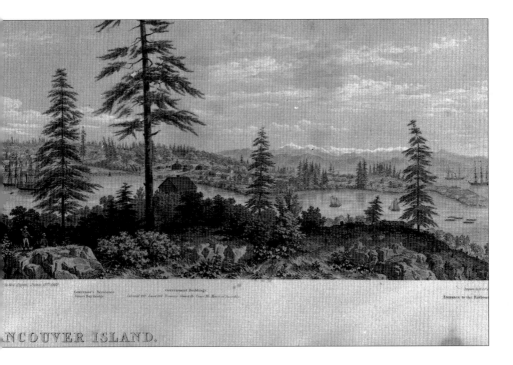

NCOUVER ISLAND.

The Wreck of the *Nannette*

THE WEATHER WAS clear the night the barque *Nannette*, bearing general cargo from England to Fort Victoria, fetched up on Race Rocks, only 18 kilometres short of her destination. The Race Rocks lighthouse began operating just three days later, on December 26, 1860. The crew and passengers of the *Nannette* escaped unharmed, but salvage operations turned into a farce of looting and fighting as word of easy pickings spread around the colony.

In a spell of fair weather at year's end, more than 100 freelance salvagers congregated at the ship's heeled-over hull. The colonial constabulary, Royal Navy personnel, and company underwriters looked on, hoping to collect recovered merchandise and evaluate salvage claims. Looting charges followed many of the participants home. Liquor was a popular target. American vessels ferried stolen cargo across the Strait of Juan de Fuca, and only a handful of pilferers was apprehended. Six native people drowned when their heavily laden canoe encountered rip tides in the area and capsized.

Nannette finally slid to her grave on February 15, but the salvors' claims and other legal action dragged on for months. Race Rocks remained one of the most feared marine hazards in the Strait of Juan de Fuca. Since *Nannette* no ships have cast up on the rocks in clear weather.

The Young City

Victoria's first 40 years were marked by exhilarating booms and fearful busts. During the fat years of the Fraser River and Cariboo gold rushes, the city enjoyed six years of privileged status as a free port.

Then a depression followed that lasted for five years. When prosperity returned in 1870, the area's immigrant population soon doubled to more than 5000. After 1871, another depression settled over the city. By 1880, Victoria had barely 6000 residents. During the railway construction boom of the 1880s, Victoria exploited its rank as the province's principal port, provisioner and manufacturer. Some 17,000 people made their homes in the area in 1890. But by 1900, after the worldwide depression of 1893-1898, Victoria's population barely topped 20,000.

For such a small community, Victoria remained richly diverse throughout the Victorian era. Native bands— Songhees, Esquimalt, Sooke, and Saanich— were an integral part of city life, trading on downtown streets and camping on the beaches. There was a small but influential French-Canadian population. Americans formed a large group in the decade after the gold rushes. Eastern Canadian immigrants took their place after Confederation.

There were significant numbers of African-Americans—most of whom moved on—and Chinese-Americans— some of whom settled and formed the nucleus of the thriving Chinatown of the 1880s. There was a community of Hawaiian workers known as Kanakas.

There were the pioneer farmers who made the perilous trip around Cape Horn from Europe to work the fertile soil. There were the mariners who worked the port—for more than 40 years the busiest north of San Francisco. And there were the workers in the factories, foundries, and mills of British Columbia's largest manufacturing centre.

Meanwhile, the English-Scottish-Irish power élite, accustomed to running the colony, continued to exploit its privileges, cultivate airs, and profess fierce loyalty to Her Majesty. After 1865, British culture was buttressed by the presence of a large Royal Navy base.

Among the influences that shaped Victoria's character, its designation as a seat of government ranks first. George Woodcock made this telling observation about the young city: "More than one traveller to Victoria was reminded of Athens and Sparta, and the comparison was not so far-fetched as it might seem. There was no Phidias or Sophocles, no Plato or Pericles, yet in the political ferment of tiny communities like Victoria and New Westminster and Barkerville,

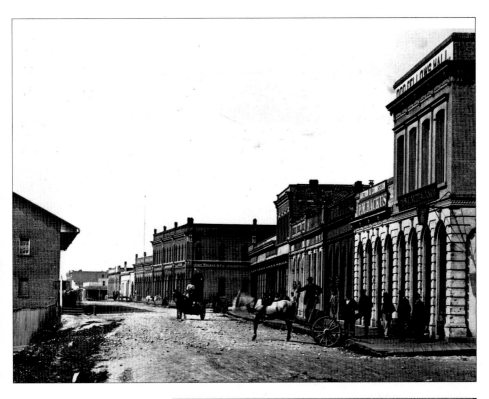

where a few hundred or a few thousand people thrust up folk leaders like De Cosmos...and produced an incessant political controversy, there was something that resembled those ancient Greek states with their small populations."

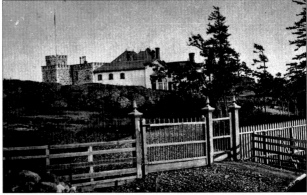

Above: *Wharf Street, looking north from the corner of Fort Street, about 1865.*

Below: *Cary Castle from Belcher Road, later renamed Rockland Avenue. Attorney General George Cary built the grandiose stone mansion on an escarpment overlooking the Strait of Juan de Fuca in 1860. The colonial government bought and refurbished the residence in 1865. The first of three governor's mansions to occupy the site, it was destroyed by fire in 1899.*

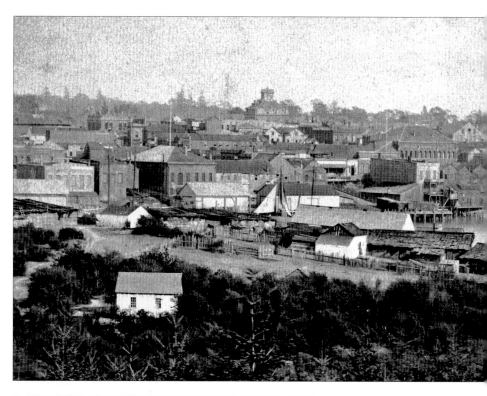

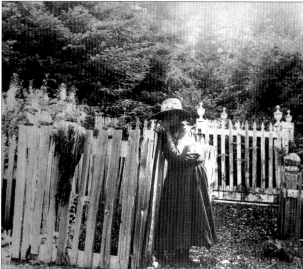

Above left and right: *Songhees Village and Victoria co-existed for more than 60 years. Repeated efforts to appropriate the Songhees property began in 1859, when a petition proposed sale of the land, the proceeds to be "devoted to the improvement of the town and harbour of Victoria." Governor Douglas responded by leasing parts of the reserve for a foundry and machine shop. The fees, supposedly for "the benefit of the Indians of the Songish Tribe," and particularly for "the improvement of their social and moral condition," disappeared into government coffers.*

Below: *A woman of the Songhees or Esquimalt band, reputedly 100 years old, at her husband's grave. The* picture was likely taken before 1872.

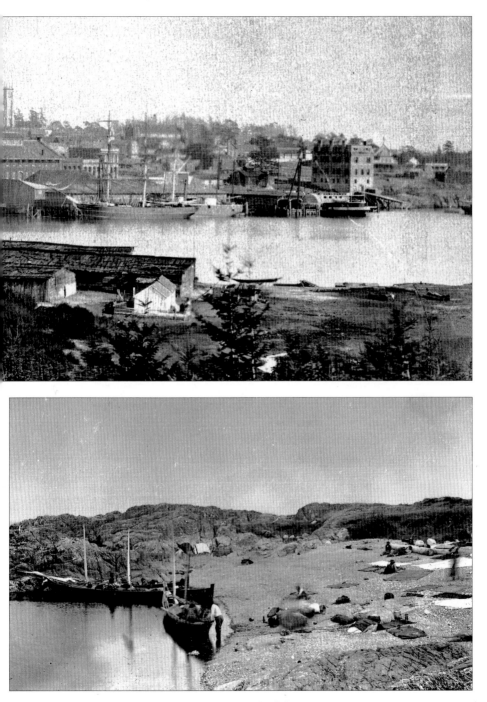

Below: *Native mariners on an Oak Bay beach. They may have been travelling to Victoria or a nearby fishing ground and paused to dry wet belongings. Such sights were common on Victoria's waterfront well into this century.*

SOOKE PIONEERS JOHN and Ann Muir typified the resourceful Scottish immigrants who settled the hinterland around Victoria during the tumultuous boom-and-bust decades of the young city. They and their four sons and a widowed daughter arrived at Fort Victoria in 1849 with seven Scottish coal miners, bound for the Hudson's Bay Company mine at Fort Rupert. John Muir was the miners' oversman. When Muir moved to Nanaimo, his position at Fort Rupert was filled by another Scot, Robert Dunsmuir, destined to become British Columbia's first industrial magnate. In 1853, the Muirs bought the property of Captain Walter Colquhoun Grant, Vancouver Island's first settler—and Scottish, of course. The Muirs' farm became the nucleus of the emerging community of Sooke, west of Victoria. Two of the Muirs' 1870s-era farmhouses, Woodside and Burnside, are still standing. For decades the Muirs operated a sawmill on Sooke Basin. The salvaged boiler from the wreck of the *Major Tompkins* supplied the power for the province's first steam-driven mill. The mill's main lines were "piles" and ships' spars. The Muirs built ships themselves—notably the 115-ton clipper *Ann Taylor* in 1861, at the time the largest craft made on Vancouver Island. Ann Muir died in 1875 and John in 1884. The mill closed forever in 1892, when the era of tall-masted sailing ships was over.

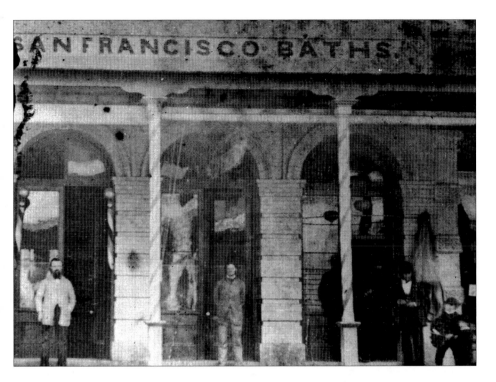

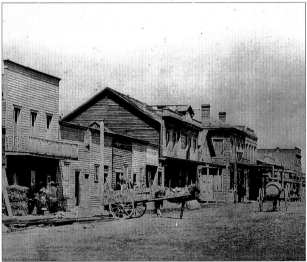

Above: *The San Francisco Bath House, one of a few downtown establishments that had water piped from Spring Ridge in the 1860s.*

Right: *Government Street in the late 1860s, looking north from Fort Street. Note the barrel-toting wagon. Beginning in 1864, Victorians bought water by the barrel from a company that carted it from Spring Ridge, east of town. In 1875, pipes began distributing water city-wide from Beaver and Elk lakes. Near the stone-faced building on the right is one of several gas street lamps installed in downtown Victoria in 1862.*

Electric lights on huge poles replaced gas beginning in 1883.

Following pages: *Police barracks and jail, built in 1862 inside the former Fort Victoria. The yard was the site of public executions. The Provincial Court House occupied the spot from 1888. See also page 111.*

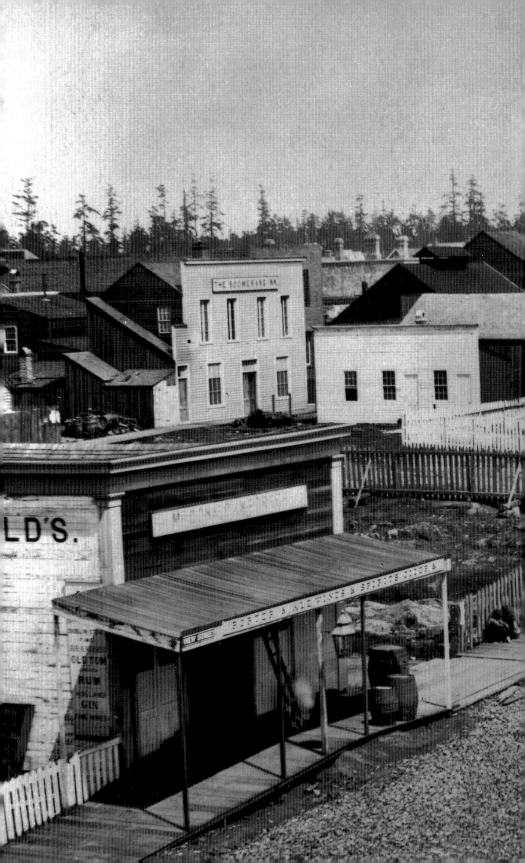

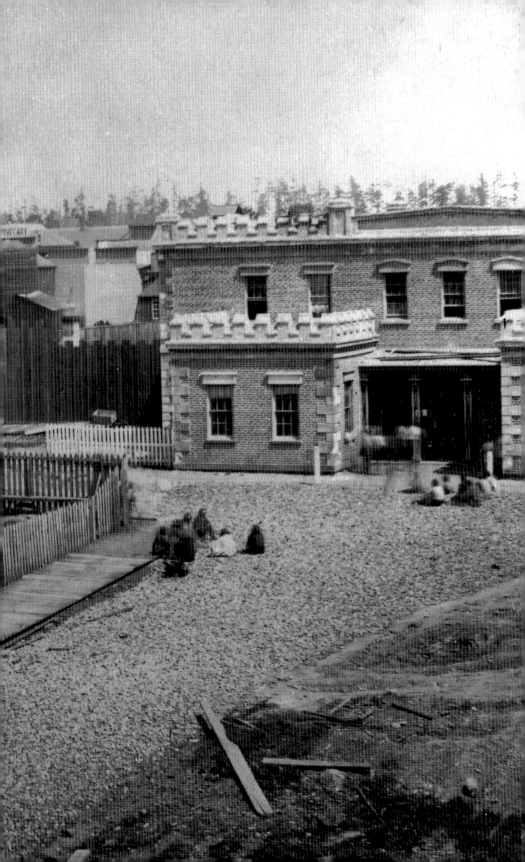

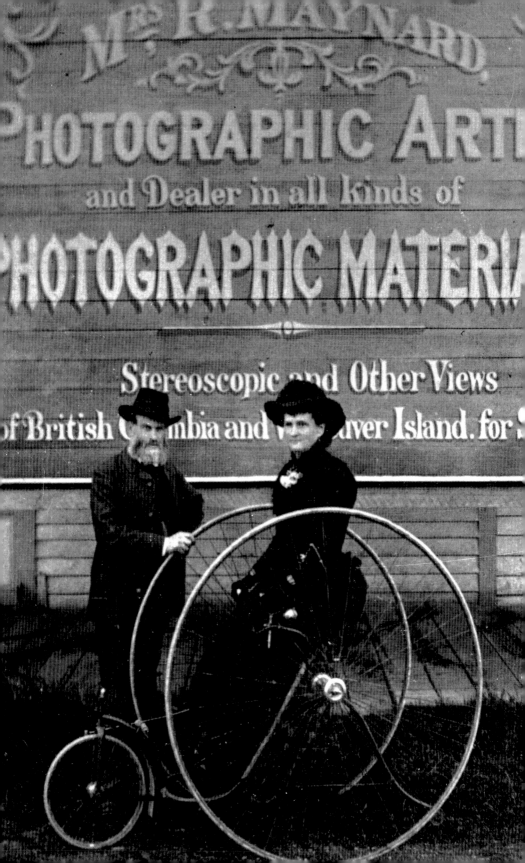

RICHARD MAYNARD (1832-1907) and Hannah Hatherly Maynard (1834-1918) migrated to Ontario from their native England in 1852. Richard, a shoemaker with a taste for gold mining and wilderness, passed through Victoria en route to the Fraser River Gold Rush. Hannah remained in Ontario with their four children and apprenticed with a portrait photographer. The family settled in Victoria in 1862. The photo above, from the early 1860s, shows Richard with, from left to right, Zela, Albert, George, and Emma. A fifth child, Lillian, was born in 1867.

While Hannah developed a solid career in studio portraiture, Richard began a succession of extended excursions with a trip to the Stikine in 1862-63. Hannah taught him photography, and he became an eminent documentor of the human landscapes of early British Columbia, while never forsaking the bootmaker's trade.

He ventured into the Cariboo District with Albert in 1868, around Vancouver Island in 1873 and 1874, to Alaska in 1879, 1882 and 1887, to the Queen Charlotte Islands in 1884, to CPR railway construction sites in the 1880s and 1890s, and to the Bering Sea in 1892.

Beginning in 1874, they plied their two crafts under the same roof at the corner of Douglas and Johnson streets, where they posed for the photo at left. In 1892, they moved into a new studio-shoe store on Pandora Avenue. For five years beginning in 1897, Hannah was the Victoria Police Department's photographer. She was able to provide both front and profile shots in one photo by positioning a mirror on suspects' shoulders, angled at 45 degrees. Albert Maynard later took over both the photography studio and the boot business.

For about 20 years, Hannah Maynard developed a repertoire of experimental effects in photography. The most widely known were the Gems, montages of children's portraits she assembled at the end of every year between 1881 and about 1895 and distributed to her clientele. Some years, Hannah incorporated previous years' Gems in miniature, creating oceans of little faces, tens of thousands in one frame. Hannah also created multiple images of herself and other people; eerie white "photosculptures" of truncated bodies, sometimes mounted on stands; and embossed portraits, the backs of the prints painstakingly hand-tooled and filled with papier-maché.

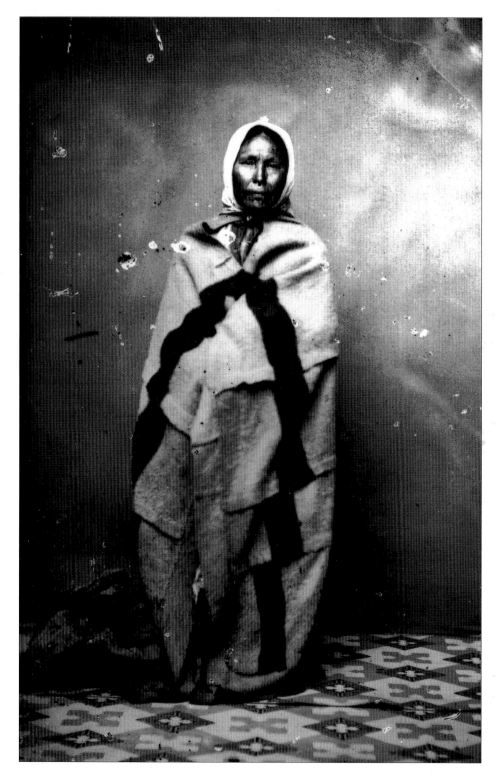

Opposite: *Mrs. Blackman, the Maynards' washerwoman, by Hannah Maynard.*

Above: *Mother and child, not identified, probably taken in the late 1870s; an example of Hannah Maynard's conventional middle-class portraiture.*

Below: *Among Hannah's many mug shots in the police archives is this one of Belle Adams.* The Daily Colonist *related the "awful crime" perpetrated in "a first floor front room in the Empire Hotel on Johnson Street" one June evening in 1898. Ms. Adams, "frenzied by the fear that her unrestrained and unnatural affection for a man not of her own race or color was no longer returned, half severed his head from his body with a razor." The man, Charles Kincaid, "staggered down the stairs and into the street, where he fell, and within a few minutes gave up his life. The woman followed him, and weeping hysterically threw herself upon the bleeding, quivering body, madly embracing it, speaking words of endearment into the deaf ears, and pleading for forgiveness and the life of the man she had struck down." She was sentenced to five years for manslaughter.*

EMILY CARR (1871-1945) was one of Canada's pre-eminent artists and writers. Her childhood memoirs, crafted in her later years and collected in *The Book of Small* and *Growing Pains*, evoke the magic of early Victoria.

The youngest of five daughters of English immigrants was born in a house made of California redwood on Carr Street, a little dirt road in the suburb of James Bay. The provincial government buildings, the Birdcages, were nearby. Carr Street "would have joined Birdcage Walk if Mrs. McConnell's cow farm had not stood in the way." Birdcage Walk ended at the James Bay Bridge. Some mornings Small, as she was nicknamed, walked with her father to the bridge. "From our gate to the James Bay Bridge wild rose bushes grew at the roadsides." Then Richard Carr would walk into town and open his wholesale store on Wharf Street.

Behind the house were gardens and an orchard, and farther east was a cow pasture. "One of the seven gates of the Cow Yard opened into the Pond Place. The Pond was round and deep, and the primroses and daffodils that grew on its bank leaned so far over to peep at themselves that some of them got drowned. Lilacs and pink and white may filled the air with sweetness in Spring. Birds nested there."

A nearby corner of the 1.6 hectare estate, the New Field, "was full of tall fir trees with a few oaks. The underbrush had been cleared away and the ground was carpeted with our wild Canadian lilies.... Nothing, not even fairyland, could have been so lovely as our lily field. The wild lilies blossomed in April or May but they seemed to be always in the field, because, the very first time you saw them, they did something to the back of your eyes which kept themselves there, and something to your nose, so that you smelled them whenever you thought of them....

The lilies were thickly sprinkled everywhere. They were white, with gold in their hearts and brown eyes that stared back into the earth because their necks hooked down. But each lily had five sharp white petals rolling back and pointing to the tree-tops, like millions and millions of tiny quivering fingers. The smell was fresh and earthy. In all your thinkings you could picture nothing more beautiful than our lily field."

Between the Carr's property and Beacon Hill Park "there was nothing but a black, tarred fence." The park was "just as it always had been from the beginning of time, not cleared, not trimmed." Carr describes a picnic outing in the park: "Mother and I squeezed through a crack in its greenery; bushes whacked against our push. Soon we came to a tiny grassy opening, filled with sunshine and we sat down under a mock-orange bush, white with blossom and deliciously sweet." Beacon Hill was "grassy, with here and there little thickets of oak scrub and clumps of broom. Beyond the hill the land was heavily wooded."

Carr's parents died before she was 16. Emily and three sisters all eventually settled, unmarried, in houses built on the family estate.

In 1890, Carr moved to San Francisco to study art. She returned to Victoria at age 21 and lived in the family house, turning the cow barn into a studio, and teaching art.

Carr made early drawings of native villages, including the modest pencil sketch above, of the village of Etedsu, during a visit to Ucluelet, a Nuu-Chah-Nulth village on the west coast of Vancouver Island, in 1899.

In 1907, Carr began to make painting trips to places on the BC coast, creating the landscapes that would become her signature.

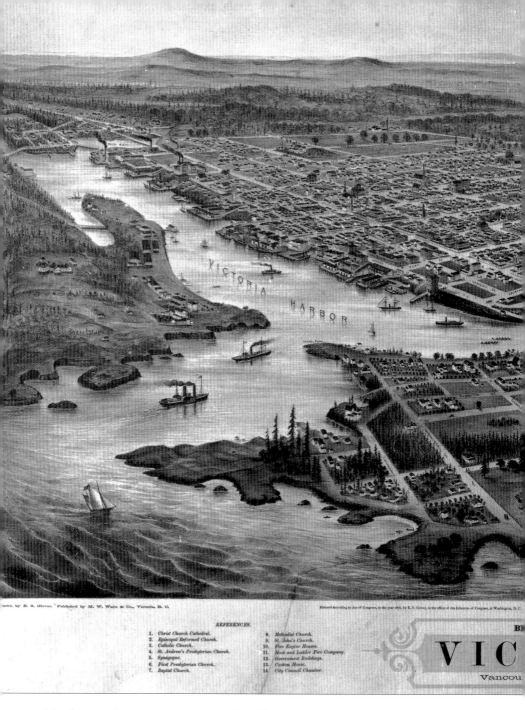

wn by E. S. Olover. Published by M. W. Waitt & Co., Victoria, B. C. Entered according to Act of Congress, in the year 1878, by E. S. Glover, in the office of the Librarian of Congress, at Washington, D. C.

REFERENCES.

1. Christ Church Cathedral.	8. Methodist Church.
2. Episcopal Reformed Church.	9. St. John's Church.
3. Catholic Church.	10. Fire Engine Houses.
4. St. Andrew's Presbyterian Church.	11. Hook and Ladder Fire Company.
5. Synagogue.	12. Government Buildings.
6. First Presbyterian Church.	13. Custom House.
7. Baptist Church.	14. City Council Chamber.

VIC

Vancou

This lithograph 1878 Bird's-Eye View of Victoria depicts the young city from the southwest. The suburb of James Bay, in the fore-ground, still had remnants of forest. Emily Carr's family home can be seen inside the V that opens towards the oval race track around Beacon Hill—it's the house on the open side of the cross street. Downtown Victoria is in the middle distance. Among buildings identified in the key

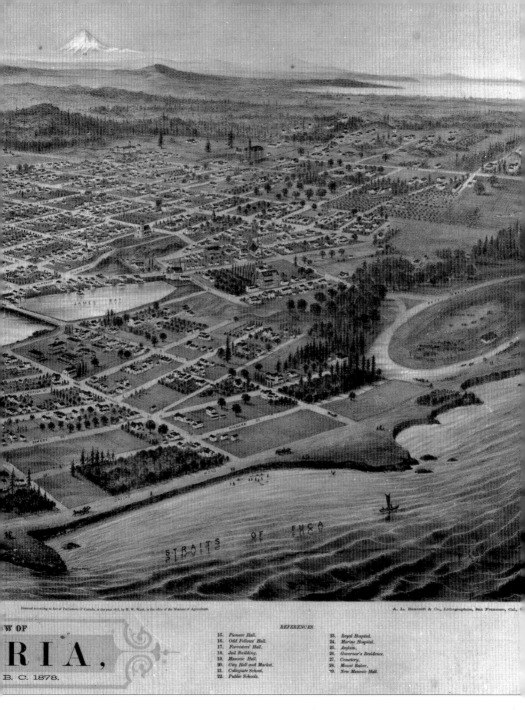

W OF

RIA,

B. C. 1878.

REFERENCES.

15. Pioneer Hall.
16. Odd Fellows' Hall.
17. Foresters' Hall.
18. Jail Building.
19. Masonic Hall.
20. City Hall and Market.
21. Collegiate School.
22. Public Schools.

23. Royal Hospital.
24. Marine Hospital.
25. Asylum.
26. Governor's Residence.
27. Cemetery.
28. Mount Baker.
29. New Masonic Hall.

and standing today are the Episcopal Reformed Church (1874), City Hall, the Custom House, and the Masonic Hall, all newly completed.

Across the harbour at left is Songhees Village. On the north side of the city, farmland or forest began roughly at Bay and Chambers streets.

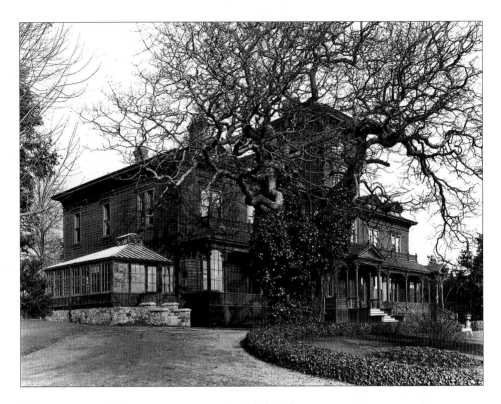

Opposite top: *View towards downtown from Beacon Hill in the 1870s. James Douglas earmarked Beacon Hill for a park as early as 1850.*

Opposite bottom: *The Colonist Hotel, originally the Park Hotel, near Beacon Hill Park, at the southeast corner of the Carr property.*

Above: *The Gonzales mansion.*

Right: *Joseph Despard Pemberton (1821-1893), a Dubliner who trained as a civil engineer. Arriving in Victoria in 1851, Pemberton was appointed colonial surveyor. He surveyed Victoria's downtown, mapped southeastern Vancouver Island, designed and constructed many early buildings, held office and established an engineering firm that today deals in real estate.*

By the late 1850s, Pemberton was Victoria's largest private landowner, with the deed to 500 hectares on the east side of Victoria—most of what is now Oak Bay—in his pocket. The story is told of a man who came into the survey office to enquire about buying land on the east side. Pemberton suggested he ride out and have a look. When the man returned, resolved to buy it, Pemberton told him he was too late—he had bought it himself! In 1885, he built a 930 square metre mansion, "Gonzales," on a hill-top site in Rockland.

These two views views from
the belfry of Christ Church
Cathedral, near the corner of
Blanshard Street and Burdett
Avenue, were taken by
Richard Maynard in the
early 1870s.

Right: Looking northeast
across Courtney, Broughton
and Fort streets. Quadra, the
cross street, fronts the city's
second cemetery, middle
right.

Below: Looking east along
Burdett toward Angela Col-
lege.

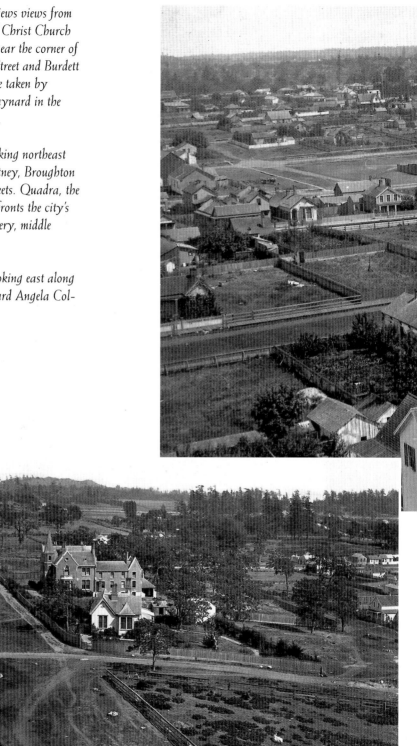

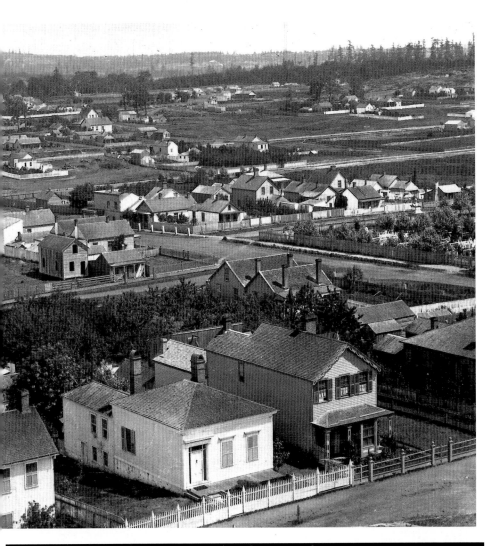

Lady Angela's Works

ANGELA BURDETT-Coutts, an English baroness, left a lasting imprint on the city. The first Anglican bishop of British Columbia, George Hills, arrived in Victoria in 1860 with an endowment of £15,000 from the rich benefactress. The baroness, it was said, had been so taken with Reverend Hills she proposed to him. A more physical manifestation of her largesse was the St. John's Church. Assembled at the corner of Douglas and Fisgard streets, it was the first Anglican church consecrated in western North America. St. John's, known as the Iron Church, was notoriously noisy when rain drummed on the roof or the wind worked its way through the seams. Lady Angela also endowed an Anglican girl's collegiate school, appropriately named Angela College, on Burdett Avenue.

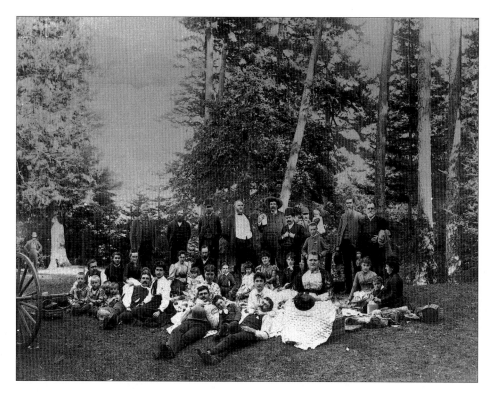

Above: *Victoria Spiritualists' Society picnic at Cordova Bay, about 1886. Photo probably by Richard Maynard. Victoria Mayor James Fell, the society's president, is standing at centre in a white waistcoat. Hannah Maynard can be seen in profile at right. She turned to spiritualism after the death of her daughter Lillian in 1883.*

Opposite, top: *Regatta, the Gorge, 1894. In the 1890s, the Gorge Waterway was Victoria's favorite boating area. The Queen's Birthday, celebrated on an extended weekend around May 24,* became the fixture for the Gorge Regatta. Thousands congregated in boats and by streetcar. There were races and contests. The fine homes that lined the waterway opened their doors.

Opposite, bottom: *Tennis at Point Ellice, the O'Reilly family home on the Upper Harbour. Mr. and Mrs. Peter O'Reilly are sitting on the bench, and Kathleen O'Reilly is in front. The four men were naval officers. The O'Reilly family moved into Point Ellice in 1867 and stayed until 1974. It was one of the fashionable homes in* early Victoria, attracting prominent English and Anglo-Irish families—notably Mr. and Mrs. Joseph Trutch, Mr. and Mrs. Joseph Pemberton, and Judge Matthew Baillie Begbie. Kathleen O'Reilly lived her entire life at Point Ellice and never married.

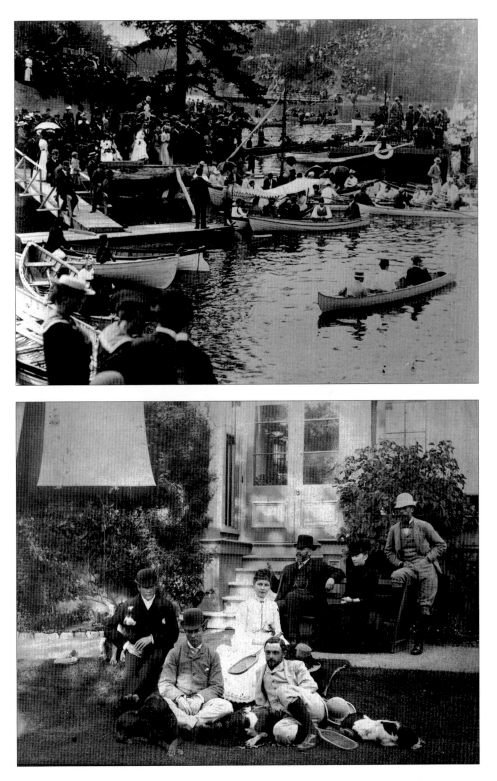

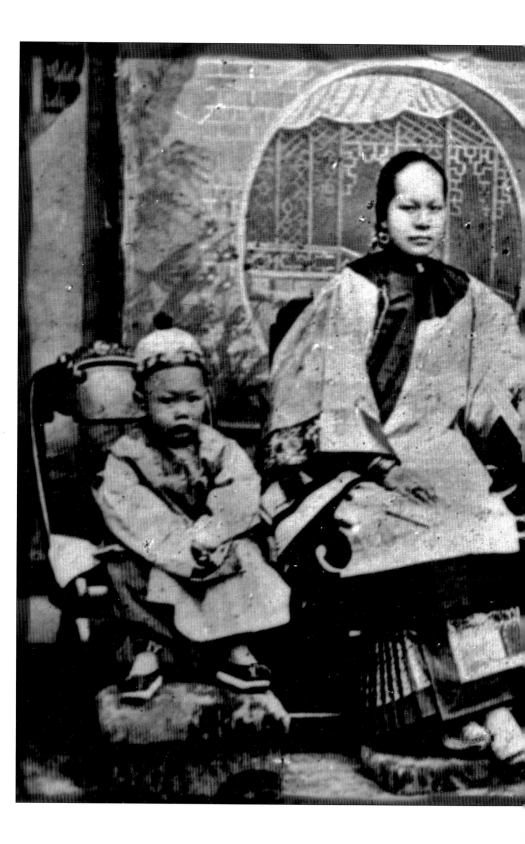

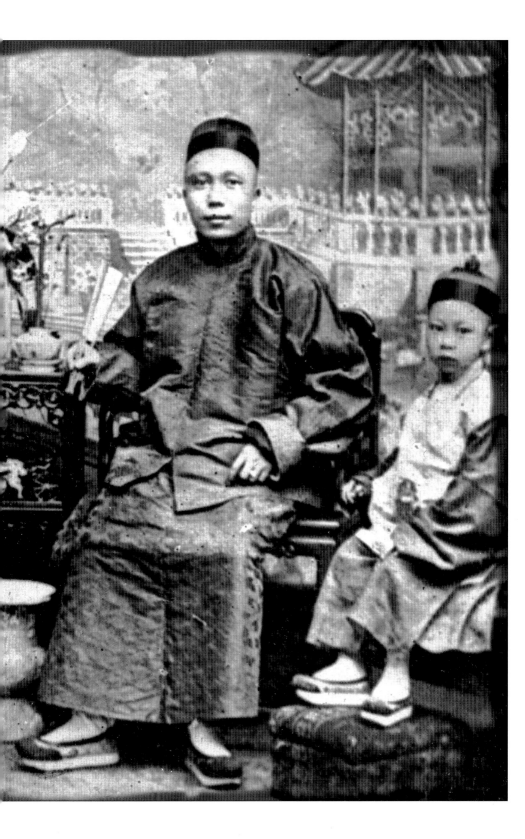

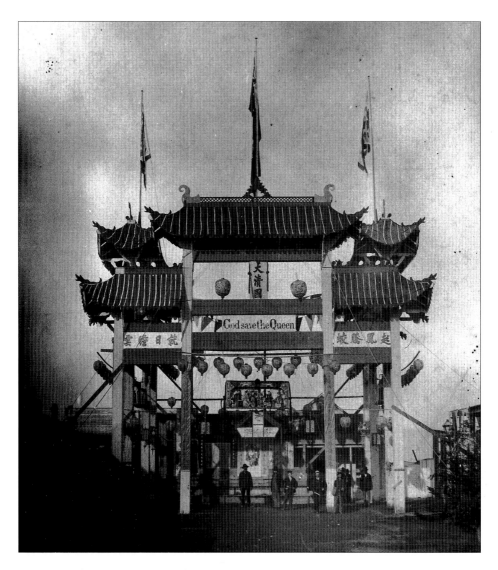

Previous pages: *Chinese family, late 1800s. Until the immigration laws were amended in the 1940s, only well-to-do merchants could afford the head tax and other expenses of supporting families in Canada. As a result, men vastly outnumbered women in Victoria's Chinatown. Those who did succeed were among the richest businesspeople in Victoria. Opium manufacture, licensed by the government until 1908, was particularly profitable.*

Above: *Chinese arch erected on Store Street for the visit of the Governor General in 1882. Victoria had the largest Chinese population of any Canadian city until about 1910. The original Chinese immigrants to Victoria were gold rush miners from San Francisco. A few hundred merchants and workers settled in Victoria to form the nucleus of a Chinatown, between Fisgard and Cormorant streets, where the core of Chinatown is today.*

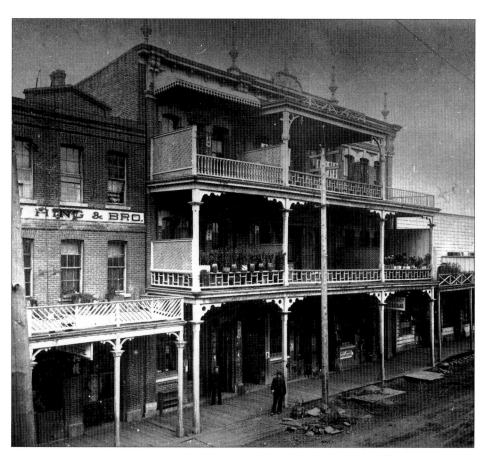

For thousands of Chinese workers who immigrated in the 1880s during construction of the CPR, Victoria was the gateway to Canada. The practice of constructing temporary archways to commemorate the visits of important people is based on Chinese tradition. Victoria's Chinese community put up arches to welcome governors general in 1876, 1906 and 1912, and the practice was imitated by other cultural and business communities.

Above: The Chinese Benevolent Association Building on Fisgard Street, 1890s. Established in Victoria in 1884, the CBA commissioned architect John Teague to design this three-storey structure, with balconies extending to the street and decorative canopies. Besides stores at street level, the building housed the association's offices, the Palace of Sages (a shrine) and the Chinese Free School. Many mixed-use Chinatown buildings also accommodated their shop-keepers' families. The CBA operated as a kind of consulate before the Chinese government established a formal presence in Ottawa in 1909. It evolved into an activist umbrella association, providing social services and intervening politically. This building and many others dating from the construction boom of the 1880s and 1890s survive today, minus balconies and other embellishments.

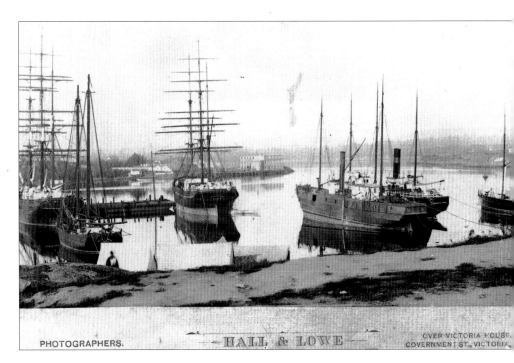

PHOTOGRAPHERS. — HALL & LOWE — OVER VICTORIA HOUSE, GOVERNMENT ST., VICTORIA.

Above: *Ships in Victoria Harbour, after 1880. The rocky shoreline drops off steeply, enabling most deepsea vessels to tie up alongside at low tide. This feature contributed to James Douglas's decision to build Fort Victoria on Victoria Harbour, rather than at Esquimalt. Mooring rings set into the rock in the 1840s continued to be used for decades after. Victoria remained the premier port in British Columbia through the 1880s and into the 1890s. But the stroke of a pen had doomed it to play second fiddle to a city that didn't even exist at the time this photo was taken. British Columbia's terms of union promised that a transcontinental railroad would be constructed within 10 years. To commercial interests in Victoria, this city was the logical choice for the terminus because of its well-developed commercial and manufacturing infrastructures. Victorians lobbied hard for a route that would cross the Chilcotin Plateau and reach Pacific tidewater at Bute Inlet—whence, they envisaged, the railroad would cross Seymour Narrows to northern Vancouver Island and so to Victoria. In 1878, Prime Minister John A. MacDonald—newly elected as Member of Parliament for Victoria—chose the Fraser River as the railway's route, for ease of engineering and because of the commercial threat posed by the Northern Pacific Railway, then nearing Puget Sound. Historian Margaret Ormsby comments: "Victoria had lost its one chance to become a great Pacific depot, strong enough, if it had easy access to the Nanaimo coal-fields, to challenge the position and power of San Francisco itself." Construction of the Canadian Pacific Railway took another eight years. The terminus was eventually located near the tiny logging community of Granville on Burrard Inlet, and the rest is history.*

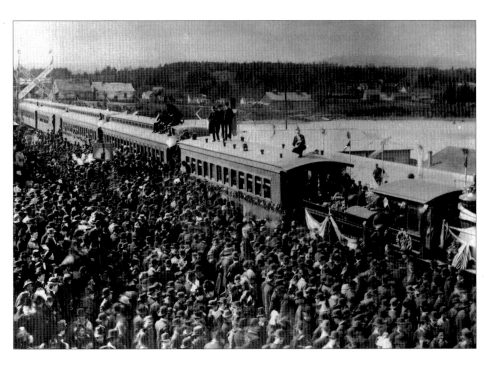

Above: *The Esquimalt and Nanaimo Railway reaches Victoria, March 29, 1888. As completed in 1886, the E and N terminated in Esquimalt. The city took the initiative to construct a swing-span rail bridge over the harbour. When the first train inched its way through the crowds to the Store Street station, Nanaimo coal baron Robert Dunsmuir, the builder, was hailed as the saviour of the city. Dunsmuir suggested that Victoria would become "a vital place in the network of railways linking North America instead of an isolated outpost of Queen Victoria's empire."*

*In fact, the railway nev-*er amounted to more than a regional service and a sop to frustrated local interests. Its checkered history dated from 1873, when the provincial government pressured the government of Canada to honour the Terms of Union by beginning construction of a railway line up the east side of Vancouver Island. The federal government reneged on the shaky deal in 1875. After construction of the transcontinental railway began in 1880, the federal government revived the island railway concept to placate Vancouver Island residents. The Canadian Pacific Railway (CPR) company dismissed the project, but Dunsmuir struck a bargain with the federal and provincial governments in 1883 to build the 124-kilometre line. Dunsmuir received fabulous concessions, including a huge construction subsidy, tax concessions, and almost 800,000 hectares of excellent forest land, with the rights to all resources. In 1905, the CPR bought the line, together with 583,000 hectares, for $1.33 million— probably the most profitable land deal the company ever made. The CPR extended the railway line 100 kilometres to Courtenay.

Above: *The inaugural run of Victoria's first streetcars on February 22, 1890. Victoria was the third city in Canada to build a streetcar system. The first cars were five metres long and carried 28 people. David Higgins, once a reporter for Amor De Cosmos's* British Colonist, *now rich and a Member of the Legislative Assembly, was president and managing director of the National Electric Tramway and Lighting Company, the first of several companies that ran the system. Two lines opened in 1890. A north-south line ran between the Outer Wharf, near Ogden Point in James Bay, and the corner of Douglas Street and Hillside Avenue. The second ran east between downtown and the Royal Jubilee Hospital, near Fort Street and Richmond Avenue, passing Higgins' mansion, Regent's Park, en route. The electricity that powered the little trolley cars came from coal-burning generators in a powerhouse on the harbour side of Store Street, north of Discovery. The car barn was nearby. Later that year, a third line began running west to the village of Esquimalt. By the time the eleventh and last line was built, in 1913, swishing through long grass in the fields of Oak Bay en route to the Uplands, the system was operated by the British-owned BC Electric Railway Company and powered by generators at the Goldstream hydroelectric plant.*

SHORTLY AFTER 1:30 pm on May 26, 1896, 142 people crammed onto a streetcar with a stated capacity of 60. It was the fourth day of the Queen's Birthday celebrations, and the crowd was intent on catching one of the highlights: military manoeuvres and a mock battle at Macaulay Point. The Esquimalt line ran from the powerhouse terminus on Store Street, across two bridges and out Esquimalt Road to the Dockyard. The Rock Bay and Point Ellice bridges were of typical construction of the day: wooden decks supported by stout wooden pilings sunk into the mud of Victoria Harbour. The overloaded car made it across the old Rock Bay Bridge—which was made to carry less than half that much weight—and turned west on Bay Street. The Point Ellice Bridge, built only in 1885, had already been declared unsafe. Three years before, passengers on the same streetcar had experienced a sickening subsidence while crossing the bridge. The pilings had been tested for rot, but the test holes had apparently been left unfilled, and no further action had been taken to lessen the hazard. Halfway across the Point Ellice Bridge, the middle span collapsed, and the car toppled into the water. Pieces of the bridge rained down, along with pedestrians and passengers in other vehicles unfortunate enough to be on the deck at the time. Some streetcar passengers were ejected through window openings. Some were rescued by nearby boaters and residents. Fifty-five people died—still the worst streetcar accident in North American history. The catastrophe forced the city to review the safety of its bridges. It also drove the already-shaky streetcar company into bankruptcy.

Above: A Victoria and Sidney Railway train chugs along Rose Street, north of Hillside Avenue. The first of three railway lines to the Saanich Peninsula, the wood-powered V & S was known as the Cordwood Limited. Service on the 27-kilometre line began in 1894 from a depot on Tolmie Avenue near Douglas Street, a block from the #1 streetcar terminus. The line was acquired by Great Northern Railway in 1902, and a year later the V & S began to operate out of a depot it shared with the fire department on Cormorant Street, near City Hall. The BC Electric Railway Company bought into the short-lived transportation boom in 1913 with the 37-kilometre-long Interurban line. Nicely appointed passenger cars wound out to Brentwood Bay and Deep Cove, where a rustic lodge (now Deep Cove Chalet) and a ferry slip were located. Canadian Northern Pacific Railway built a

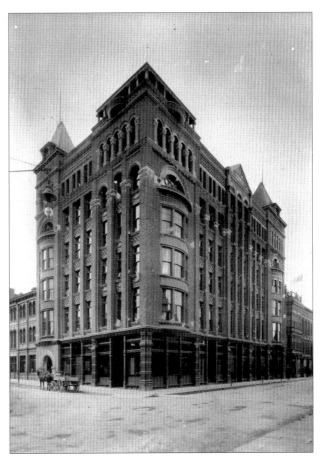

Above: *The Driard Hotel, at the corner of View and Broad streets, in the 1890s. Reputed to be the finest hotel north of San Francisco, the Driard took its name from a French-born early immigrant to Victoria, Sosthenes Driard, who bought the St. George Hotel at the corner of View and Douglas in 1871 and died in 1873. Under subsequent ownership, the hotel was damaged by fire, renovated and enlarged by 225 rooms, described as be-* *ing "the acme of luxury." For a decade the Driard's only peers were the Dallas Hotel, near the Outer Wharf, and the Mount Baker Hotel, on Oak Bay. In 1908, the Driard's reputation was eclipsed by the opening of the Empress Hotel. After fire damaged the building in 1910, it was converted to a department store annex, and so it remained until 1988. A corner of the Driard's façade has been reconstructed in the Victoria Eaton Centre.*

third line to connect its up-island line with docks at Patricia Bay in 1917. By 1919 only the BCER line was serving passengers.

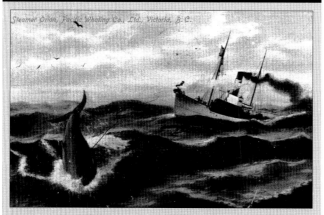

Steamer Orion, Pacific Whaling Co., Ltd., Victoria, B.C.

VICTORIA WAS the province's largest sealing and whaling centre for 50 years. The boom years of the two industries over-lapped.

Pelagic (open-water) sealing was in its prime in the 1880s and 1890s. The fleet of more than 60 boats moored in the Upper Harbour. Employing as many as 1500 people, including 500 Natives, it followed the seal herds north to their Bering Sea breeding grounds every summer. In 1894, a peak year, sealers landed near-ly 100,000 skins at Victoria. After 1891, international concern for the depleting herds led to a negotiated ban on sealing in the Bering Sea. The ban took effect in 1911, but the take had already dwindled pathetically.

Whaling was a small-scale industry in the Strait of Georgia in the 1860s. A partnership based on the Saanich Peninsula hunted hump-back whales in Saanich Inlet. The firm soon moved to Cortes Island and, like other compa-nies, went out of busi-ness as the animals dis-appeared from the straits. In 1904, two sealing vet-erans, Sprott Balcom and William Grant, formed the Canadian Pacific Whaling Company, the first of a series of firms that built up a fleet of a dozen steamers, begin-ning with the 29-metre-long *Orion*, above, that worked the west coast migration routes for 15 years. After World War I, international competition made whaling a marginal enterprise.

Above: *The CPR Empress of Japan at Victoria's Outer Wharf. Beginning in 1891, the three speedy white Empresses, Japan, India, and China, called in at Victoria en route to and from Vancouver—a*

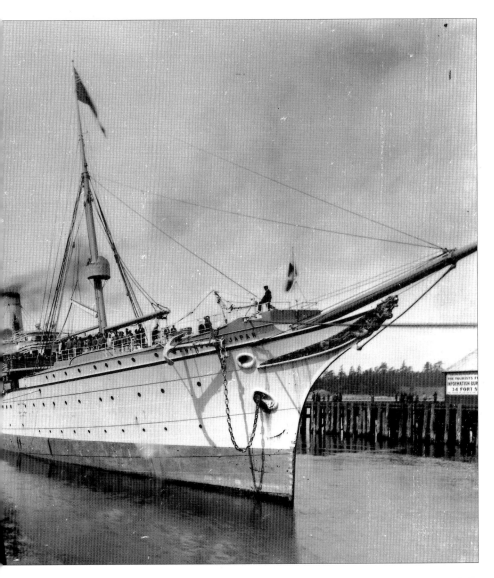

reality that galled many Victorians.

Right: *Warehouses and steamers on the east side of Victoria Harbour, before 1900. The Hudson's Bay Company store is on the left.*

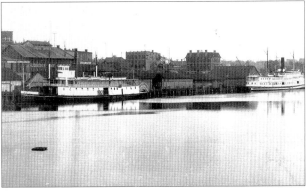

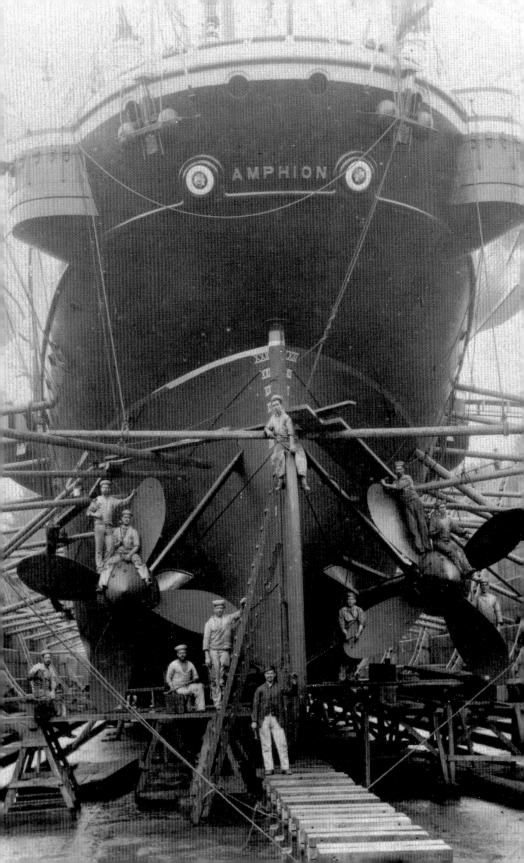

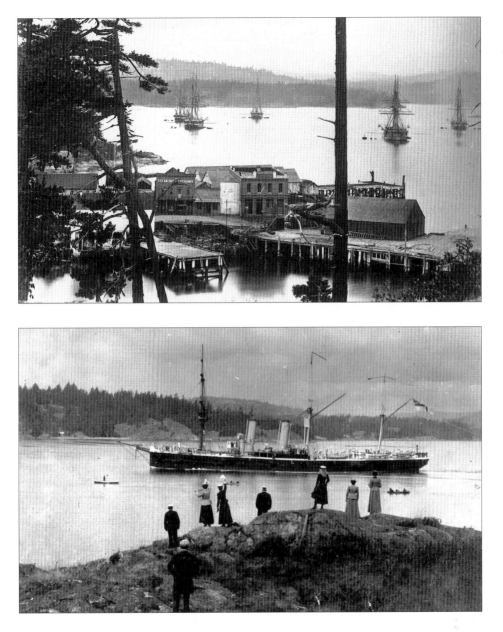

Opposite: *HMS Amphion in the original Esquimalt drydock, 1889. The drydock was completed in 1887 as part of Canada's commitment to British Columbia under the Terms of Union.*

Above: *The Royal Navy's Flying Squadron at anchor in Esquimalt Harbour. First used by the Royal Navy in 1848, Esquimalt Harbour was chosen Pacific headquarters in 1865.*

Below: *HMS Amphion leaves Esquimalt Harbour in 1889 to return to the United Kingdom to "pay off"—discharge her commission. She returned to complete two more commissions.*

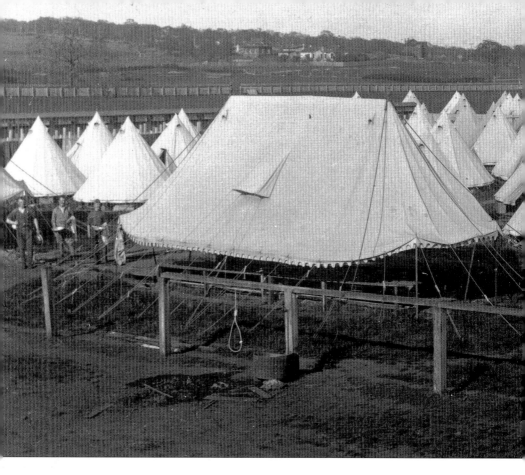

Above left and right: *Army camp at Willows. The Victoria Battery of Garrison Artillery was established as a unit of the Canadian militia in 1878. By 1906, a local militia unit, the 5th BC Regiment Canadian Artillery, was "among the largest and best trained regiments in Canada."*

Left: *Officers of the Garrison Artillery at a camp in Beacon Hill Park.*

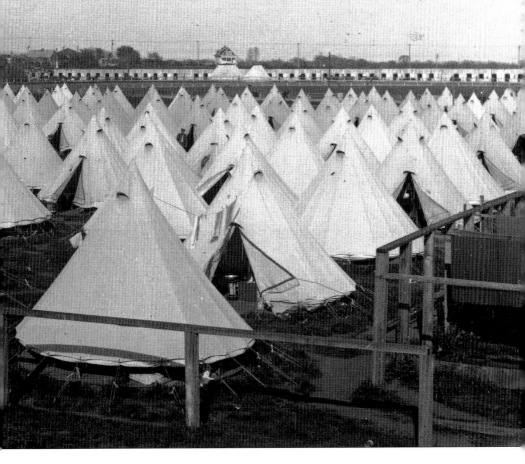

Right: *The 5th Regiment Royal Horse Artillery demonstrating its firepower at Macaulay Point, probably during the annual Queen's Birthday celebrations in May. Nearby Work Point Barracks, established as a Canadian military base in 1887, was manned by British troops from 1893 to 1906.*

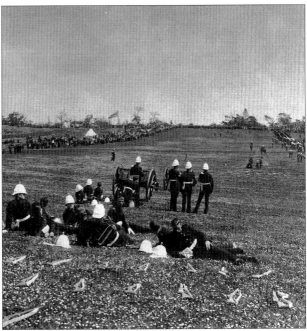

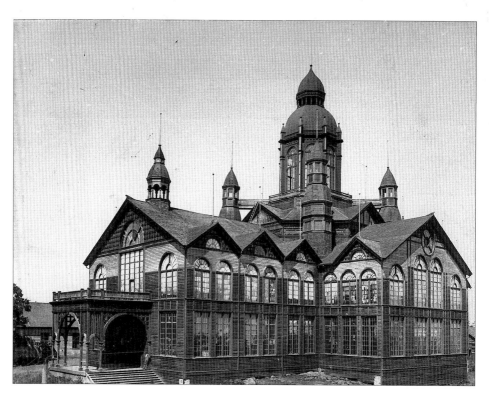

Above: *Willows Exhibition Building, constructed near Oak Bay in 1899 by the BC Agricultural Association and destroyed by fire in 1907. The 1900-square-metre building was the centrepiece of Willows Fairground. The Willows racetrack was considered the best in the region.*

Opposite top: *Cadboro Bay was the setting of the largest Native community in the area before the establishment of Fort Victoria. Uplands Farm, established by the agricultural arm of the Hudson's Bay Company in the 1840s, took in the area from Cattle Point to Cadboro Bay.*

By the turn of the century, Cadboro Bay was a picturesque summer resort area. A hotel stood near the beach for several decades.

Opposite bottom: *The seaside Mount Baker Hotel, on the south side of Oak Bay, opened in 1893 and was destroyed by fire in 1902. The Duke and Duchess of Cornwall and York (the future King George V and Queen Mary) stayed there in 1901. The boat at the dock was Tilikum, a 50-year-old, 12-metre cedar dugout canoe from Clayoquot Sound, reinforced with oak frames and rigged as a schooner. Its owner, Claus Voss, a German-born Victoria hotel-keeper, embarked on a 65,000-kilometre solo voyage around the world in Tilikum the same month this photo was taken.*

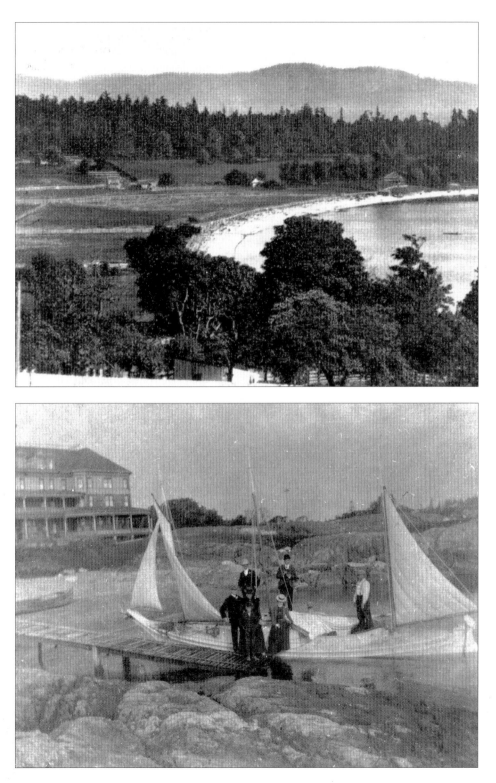

The brand-new British Columbia Parliament Buildings loom above the Birdcages. Constructed in stages between 1893 and 1916, the imposing pile symbolized the province's emerging wealth, while ensuring that Victoria remained the capital city. It was denounced as scandalously extravagant. The new Assembly Hall's shining Italian marble walls and carved oak Speaker's throne did nothing to calm the debate.

Months after the official opening of the Parliament Buildings in February 1898, John Turner, last of five premiers in the loose coalition known as the "Smithe Dynasty," lost most of his supporters in a general election. BC voters repudiated the coalition government's policies of making large land grants to railway companies.

Turner tried to patch together a new coalition. But Lieutenant-Governor Thomas R. McInnes didn't allow Turner to face the Legislative Assembly and be voted down on a "money bill"—one of the pillars of responsible government. He just dismissed Turner. The mantle fell on Charles Semlin, Leader of the Opposition in the previous parliament. Semlin's coalition included the obnoxious Joseph ("Fighting Joe") Martin, a Vancouver lawyer and Liberal supporter, whom he appointed Attorney General. Martin's abrasive personality made enemies in the cabinet, and Semlin fired him within a year.

Early in 1900, the government's electoral redistribution bill was defeated by one vote. Semlin refused to resign because it wasn't a money bill. McInnes dismissed Semlin nonetheless—again snubbing the principle of responsible government—and asked Joseph Martin to form a government.

The scene that unfolded on February 28, 1900, was unprecedented in parliamentary history. The Assembly supported 28 to 1 a motion of non-confidence in Martin, and when McInnes arrived at the Parliament Buildings the same day to prorogue (wrap up) the session, James Dunsmuir led the members out of the hall. Only Martin and the Speaker remained. The humiliated McInnes read his speech to empty benches and the hostile public in the galleries. He departed with jeers and cat-

calls ringing in his ears, and the renegade MLAs returned amid wild cheering.

Joseph Martin has the distinction of being the premier with the shortest term in British Columbia's history: three and a half months. Martin's champion, T.R. McInnes, also enjoys a dubious honour: he is the only lieutenant-governor of the province to be fired. After the election of June 1900, Prime Minister Wilfred Laurier acquiesced to an opposition caucus demand that McInnes be replaced.

James Dunsmuir formed the next government, and Joe Martin was Leader of the Opposition. He was disliked, as always, and his job was sought by an up-and-coming politician, Richard McBride, who resigned as Dunsmuir's Minister of Mines in order to improve his prospects. The opposition caucus voted McBride their leader at the beginning of the spring 1902 session. But Martin didn't give up without a fight.

At the opening ceremonies, Martin slipped behind McBride while he was standing at prayer and took the leader's seat. McBride supporters tried to dislodge Martin by force, and Martin's cronies waded into the fray. The rivals' supporters manoeuvred their desks and chairs about the floor of the Assembly in search of spatial advantage—looking, one reporter wrote, "like snails carrying their houses about on their backs."

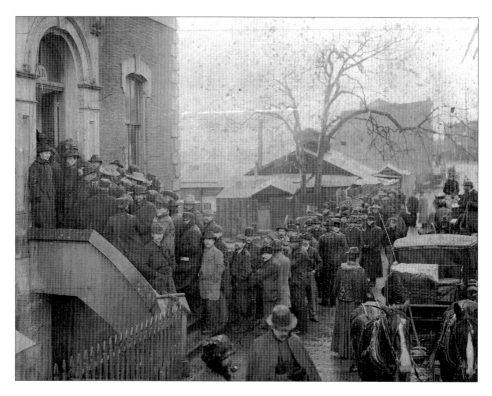

Above: *Klondike miners lining up at the Custom House on Wharf Street. Canada Customs bonded supplies for goods bought in Canada, to enable miners to enter US territory duty-free. This exemption was soon nullified by US authorities charging exorbitant fees to "convoy" bonded supplies across 24 kilometres of Alaskan territory.*

Opposite: *Klondikers with outfits ready for shipment at E.J. Saunders & Company on Johnson Street, "the largest and best equipped miners' outfitting establishment in Victoria," in April 1898.*

In July 1897, ships docked in San Francisco and Seattle carrying gold from the Yukon and the miners it had made rich. News of the huge strike on the Klondike River flashed around the world. Within a month, the first waves of an estimated 100,000 gold- and adventure-hungry people were crowding through West Coast ports en route to the Yukon. Some abandoned jobs and families. Others sought release from the terrible effects of a four-year economic depression.

Victoria advertised its provisioning and transport facilities widely. Victorian Roger Monteith, 12 years old in 1897, remembered: "You would see what they called 'Klondike sleighs' hanging up outside the stores here. Some of the prospectors would buy high boots up to the knees and various outdoor stuff and a Klondike sleigh and a certain amount of food, and they'd rustle around for dogs. You'd have to keep your dogs chained up then. Any sort of dog—a setter or anything else that could pull a sleigh—they'd get him aboard."

A correspondent for Harper's Weekly, Tappan

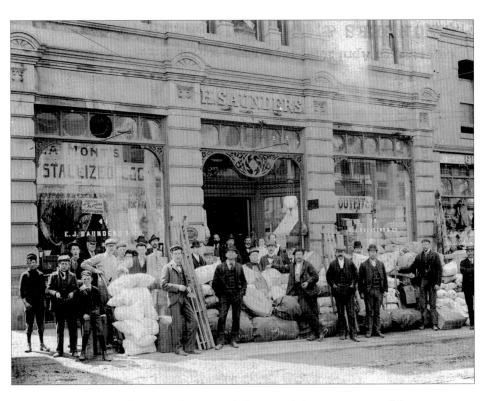

Adney, passed through the city in August 1897 and reported:

"The horses, alleged to be pack-horses, that are being brought into Victoria for sale amuse everyone greatly. There are ambulating boneyards, the infirm and decrepit, those afflicted with spavin and spring-halt, and many with ribs like the sides of a whiskey-cask and hips to hang hats on....Till now they have been without value or price.... It is ludicrous to see some of their owners, who a month ago would have fainted in their tracks at the sight of five dollars, now,

when you ask the price, shift about, swallow once or twice, and say, 'Twenty-five dollars.'"

No rust bucket in Victoria's ageing coastal transport fleet was too rusty to be enlisted to bear the human tide northward. Adney wrote:

"The steamer Bristol, a large steel collier, was chartered on a few days' notice....She was hauled into the Outer Wharf, and the carpenters went aboard with scantling and converted her entire hold into stalls two feet in width for horses; and there were stalls on deck, and hay on top of them. Rough bunks

were put in, filling every available spot on the ship....Scores of men were at work building scows, with which to lighter the freight ashore at Skagway...loading the bags containing the miners' supplies, and hoisting one by one the five or six hundred horses aboard.... After leaving, the ship returned to port to adjust her top load, after a delay of four days beyond the advertised time of sailing, during which time the poor animals were crowded in close rows, with no chance to lie down, not even chance to breathe. The men were hardly better off than the horses...."

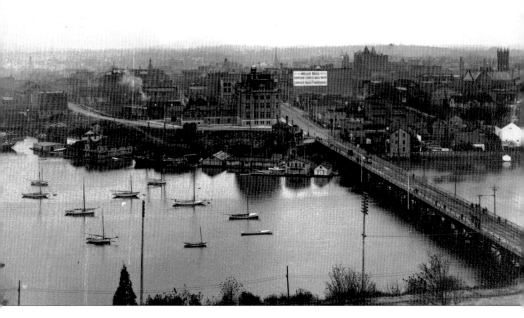

Above left and right:
Victoria at the turn of the century. Photo by D.D. McTavish, taken from the Parliament Buildings. James Bay is the body of water to the right of the bridge. At the far end of the bridge to the left is the new Post Office building.

Right: *Queen Victoria celebrated her 60th year on the British throne on June 20, 1897. The longest-reigning British monarch died on January 22, 1901, at the age of 81.*

Victoria's heyday was the decade before the turn of the century. The little city boasted a streetcar system, a telephone system, electric light, and running water; vigorous ports in two harbours, with up-and-coming shipyards; a solid commercial and mercantile district; buildings of cosmopolitan design, like Weiler's department store, with its lighted show windows; government buildings of metropolitan grandeur; stately homes and gardens in Rockland and on the waterfront; golf clubs, a yacht club, rowing clubs, parks, and race tracks.

Few of the city's nearly 21,000 residents took note that the economic orientation of the province was shifting away from Pacific shipping lanes and towards the transcontinental ribbon of steel. In 1893, the port of Victoria was still the largest in British Columbia, handling three times as much of BC's export-import trade as young Vancouver. By 1899, the port of Vancouver had the upper hand. By the same token, Victoria was the manufacturing centre of British Columbia in 1891, with sizeable salmon canning, metal- and wood-working, flour milling, opium manufacturing and other industries. Over the decade, Victoria's manufacturing production declined by more

than 40 percent, while the province as a whole experienced a heady upswing in production—more than 60 percent.

Slowly but surely, Victoria was cut out of the action. The city thrived on the shipment of Vancouver Island coal to California until the 1890s, when US railroad companies started powering locomotives with liquid fuels. Increasingly, the fields of southeastern British Columbia produced the bulk of BC's coal, and it went east on the CPR's Crow's Nest Pass route. The discovery of large metal orebodies in the Kootenay region triggered an in-dustrial explosion in southeastern British Columbia—exploited by US capital. Massive settlement of the prairies stimulated a boom in housing construction, which the CPR fed with BC lumber from forests close to the rail lines.

As locally owned companies fell on hard times, they became prey to takeovers by outside money. Two Victoria banks failed in the 1890s. The Bank of British Columbia was taken over by the Canadian Bank of Commerce in 1900, and its operation moved to Vancou-ver. Such changes were symbolic of the passing of the old order.

Host to the World

The romance of the northwest coast and Victoria's salubrious climate drew tourists from San Francisco as early as the 1870s. An 1890 *Tourist's Pictorial Guide and Handbook* rhapsodized about "dear, ever beautiful Victoria, whose pristine charms increase with years," while "the fame of its beauty and climate are being noised abroad, receiving the highest praise from every visitor."

In 1901, the Canadian Pacific Railway bought a controlling interest in the Canadian Pacific Navigation Company, fired its directors and appointed James W. Troup as manager. Troup, a Columbia riverboat captain from Oregon, masterminded the creation of a fleet of elegant cruisers, a smaller version of the CPR's transoceanic Empress fleet, for service on protected coastal waters. In 1904, the speedy *Princess Victoria* began daily service between Victoria, Vancouver and Seattle. The Seattle-based Puget Sound Navigation Company weighed into the trade with the SS *Chippewa* and *Iroquois* in 1907. The two lines dominated intercity and up-coast routes until the 1950s.

Soon the James Bay mudflats were transformed into the centrepiece of the harbourfront. The city filled in the bay, and the CPR built a luxury hotel on a forest of pilings in 1908. The Empress Hotel became a magnet for travellers and summer vacationers from all over North America and the British Empire. By 1930, the company had added huge wings to the hotel and built the nearby Marine Terminal Building and the Crystal Garden.

Besides tourists, the passenger ships brought an influx of latter-day settlers with substantial savings accounts, from Britain, the Empire, and Eastern Canada—the first wave of Victoria's ever-growing retirement community. Real estate and construction boomed, fueled by speculation surrounding the completion of the Panama Canal. Between 1906, when James Douglas's Fairfield Farm was subdivided and the municipalities of Oak Bay and Saanich incorporated, and 1913, when the bubble broke, the city's housing stock more than doubled.

Meanwhile, the city slowly lost its traditional employment base. Victoria's manufacturing sector continued to shrink. The Royal Navy removed some 1000 personnel from Esquimalt in 1906. The Canadian Naval Service took charge of the base, but Esquimalt came into its own as a command and supply centre only in the 1940s.

There were some bright spots. The shipbuilding industry flourished. The Ogden Point breakwater (completed in 1917) and docks (1920) and the second Esquimalt drydock, largest in the world (1926), helped Victoria regain its status as an important port.

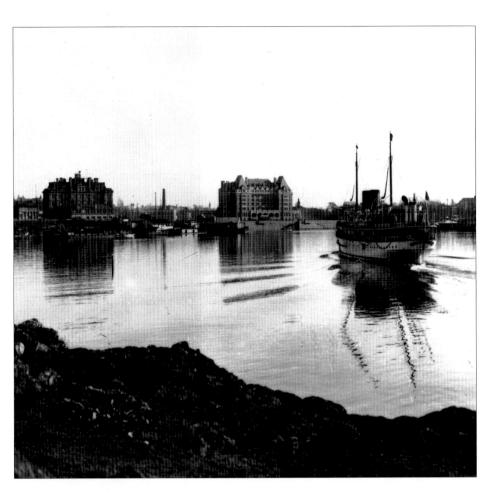

Above: *The Puget Sound Navigation Company's SS Chippewa entering Victoria Harbour. The newly completed Empress Hotel (right) and the Post Office (left). The Seattle-based company, known as the Black Ball Line, competed with the CPR's Princess ships during a period when the elegant cruisers provided almost the only service between the port cities of British Columbia and Washington.*

Left: *Richard McBride (1870-1917) was the first premier of British Columbia born in the province, the youngest to assume office (at 32), the first to form a government under the Conservative Party banner, and the only BC premier to be knighted. During the 12 years he held office, the government established the BC Forest Service and the first provincial parks.*

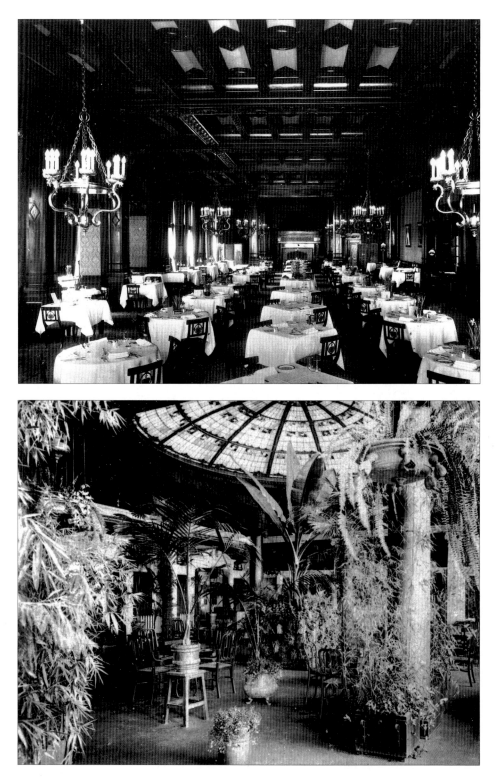

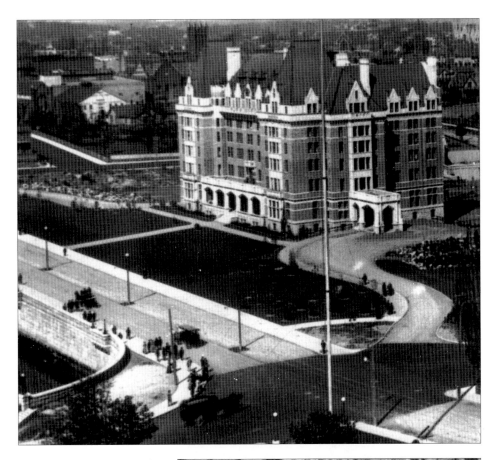

When it opened in 1908, the Canadian Pacific Railway's Empress Hotel became a destination in its own right.

Opposite top: *the dining room.*

Opposite, bottom: *the Palm Court.*

Above: *the newly completed hotel on the filled-in mud flats of James Bay.*

Right: *the Conservatory.*

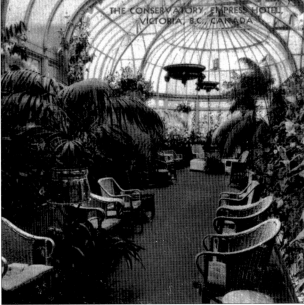

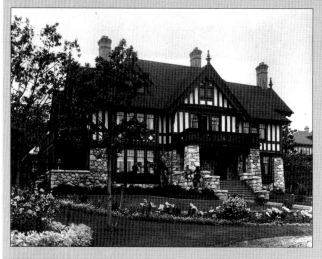

VICTORIA'S pre-eminent residential architect, Samuel Maclure (1860-1929), designed hundreds of houses for Establishment families. Born in New Westminster, Maclure studied building design and construction while working as a telegraph operator for the Esquimalt and Nanaimo Railway in Victoria. As a sideline, he offered instruction in painting. At 29, he asked for the hand of Margaret "Daisy " Simpson, an 18-year-old student and the step-daughter of a Presbyterian minister, who rejected the match—whereupon Sam and Daisy eloped to Vancouver and were married in his sister's home. The family story has it that when Daisy didn't appear at dinner, her brother raced to the harbour and scrutinized the passengers boarding a steamer for Vancouver. Daisy walked past disguised as an old lady with a cane. The Maclures settled in New Westminster but returned to Victoria in 1892.

In 1893, Maclure made his mark with the sophisticated Temple Building on Fort Street. He parlayed his connections into a fruitful association with the Dunsmuir family. In 1899, he was approached to design a house for Robin Dunsmuir—a wedding gift from his father, James Dunsmuir. Maclure was appointed architect for the second Government House while Dunsmuir was premier of British Columbia Dwarfing all his other work is Hatley Park, James Dunsmuir's gigantic country estate.

Maclure's most distinctive architecture, however, appears in the large middle-class family homes in Rockland and Oak Bay, typically with Tudor-style timbers and stonework or wide chalet-style gables, or in the shingled Craftsman style. In his later years, Maclure designed an innovative style of bungalow with economical board-and-batten exteriors. Maclure houses are an important constituent of Victoria's residential character and one of the main determinants of the city's celebrated Britishness.

Maclure was also a talented landscape architect. He provided many designs for the Robert P. Butchart family during the evolution of The Butchart Gardens at their Tod Inlet estate, Benvenuto.

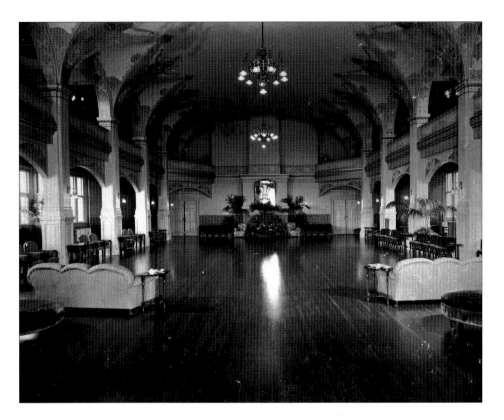

Opposite: *One of Samuel Maclure's best-known designs was this trend-setting Elizabethan Revival home on Rockland Avenue, built in 1905 for Biggerstaff Wilson, son of one of the founders of W. and J. Wilson Clothiers.*

Above: *The ballroom of the second Government House, designed by Samuel Maclure (with his family, **right**) and Francis Rattenbury and completed in 1903. Rattenbury, Victoria's principal institutional architect, had a downtown office adjoining Maclure's for many years.*

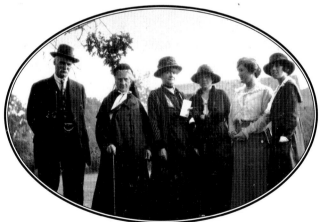

The walls and ceiling of the ballroom were elaborately decorated with frescoes by Maclure's friend James Bloomfield. Legendary warriors of Northwest Coast

First Nations rose from the column capitals, their arms extended, bearing shields on their breasts with totemic designs. Repainting in the 1950s obliterated the frescoes.

The Dunsmuir Style

MR. AND MRS. James Dunsmuir pose (middle row, centre) with their eight daughters and two sons and the extended family, around 1908, when he was lieutenant-governor of British Columbia. Dunsmuir (1851-1920) was heir to BC's first business empire. He commissioned Samuel Maclure to design Hatley Park in 1908. The huge sandstone mansion was deemed the finest residence in Canada. It was surrounded by 240 hectares of gardens, farmlands and forest, with moorage for Dunsmuir's yachts in Esquimalt Lagoon.

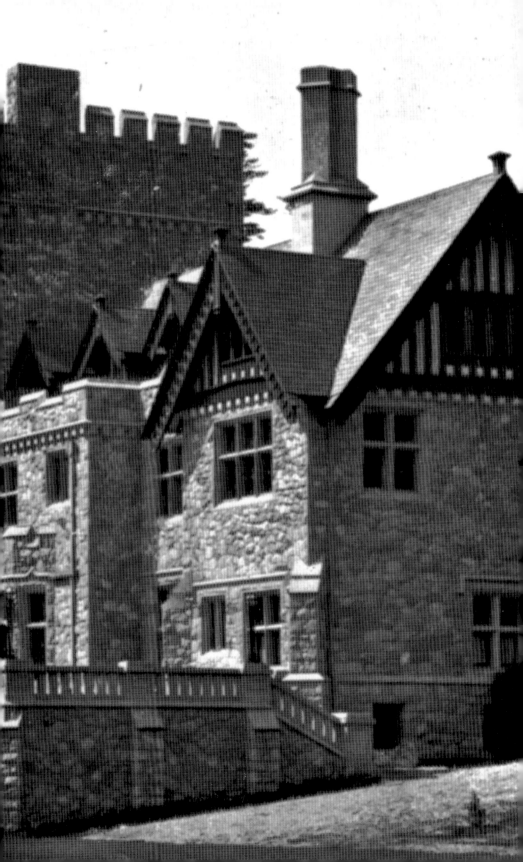

Victoria Harbour in 1912. At left are the CPR Coast Steamship docks, with Princess Victoria *at the front berth. The industrial neighbourhood of Laurel Point is behind; at right are Grand Trunk Pacific docks.*

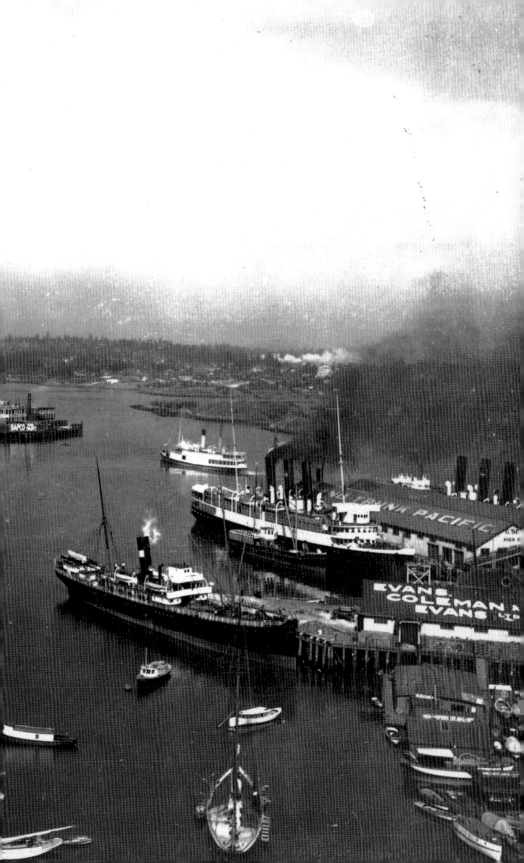

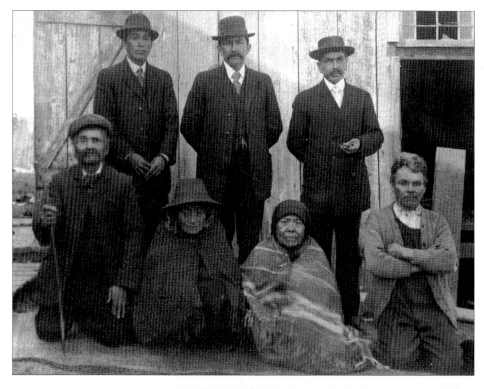

Above: *In 1911, the Songhees Band accepted a cash deal that transferred their lands on Victoria Harbour to the province, and they moved to a new reserve on Esquimalt Harbour.*

Right: *Students of St. Ann's Academy, about 1906. The Sisters of St. Ann established a Catholic convent and girls' school in a log cabin near Fort Victoria in 1858. From 1871 to 1973, the academy occupied a large school and residence on the site.*

Opposite: *The Chinese Imperial School opened on*

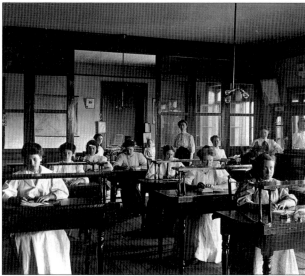

Fisgard Street in 1909. Financed and built by the Chinese Benevolent Association, it was renamed the Chinese

Public School after the establishment of the first Chinese republic in 1912.

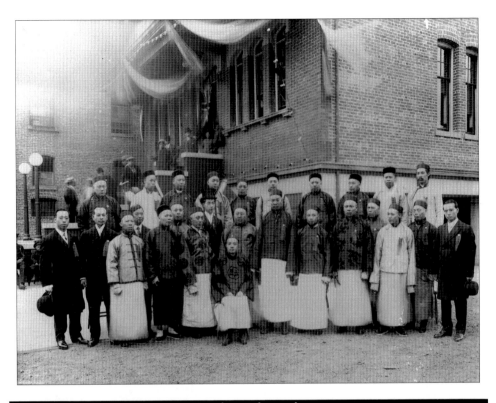

Racist Victoria

NATURALIZED CHINESE residents were denied the right to own property for many years; the right to vote was not conferred until 1949. Many displays of prejudice were more blatant. When the Chinese community bought land on Christmas Hill for a cemetery, the mourners at the first burial procession were driven away by neighbours with shotguns.

Efforts to discourage Chinese immigration began with the imposition of a $50 head tax by the federal government in 1885. In 1903, during the period that the Asian population of British Columbia peaked at more than 10 percent of the total, the head tax was raised to a whopping $500.

For decades, the bulk of available jobs outside the Chinese community were domestic work and fish packing. In 1905 and 1907, the provincial government tried to deny entry to Chinese and other Asian people by adopting language requirements for immigrants. These initiatives were variously disallowed and declared beyond the power of the provincial government. In 1908, however, the Victoria School Board ruled that only Chinese children born in Canada could attend public schools.

The movement to exclude "Asiatics" from employment in Canada continued to gain strength until Canada's racist Chinese Immigration Act of 1923 closed the doors on further entry. The act was repealed in 1947.

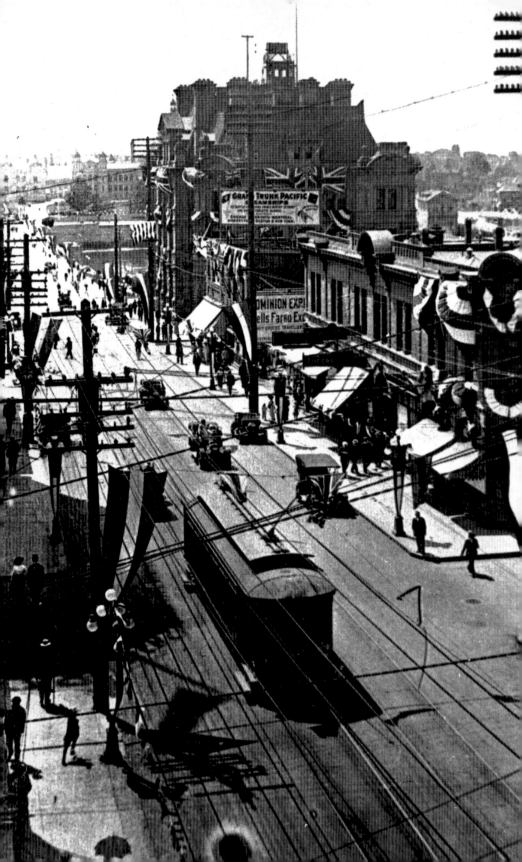

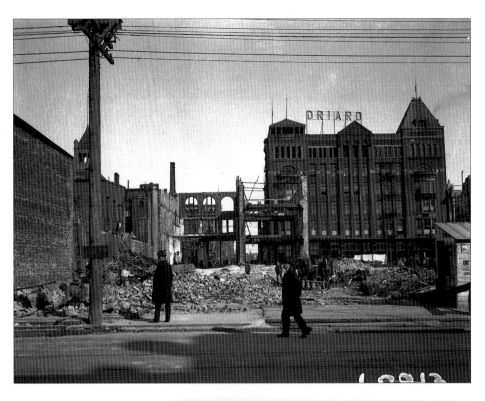

Opposite: *Looking south along Government Street, about 1912, at the height of the city's real-estate boom.*

Above: *The fire in the Arcade Block on Government Street in October 1910 had a lasting impact on Victoria's downtown core. An entire block was destroyed, from the Five Sisters Building, at the corner of Government and Fort, to Trounce Alley. When the rubble was cleared away, View Street was extended from Broad to Government. During the first year of World War I, trenches were dug in the va-*

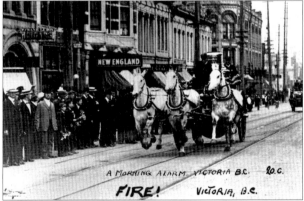

cant spaces. Soldiers gave Victorians a simulated tour of the Western Front for a quarter. David Spencer's department store reopened within weeks of the fire in the Driard Hotel building, and a new Spencer's department

store went up on the site of the old Arcade. It, too, was destroyed by fire in 1922.

Below: *A "steamer" (horse-drawn steam pumper) speeds down Government Street during a parade, about 1911.*

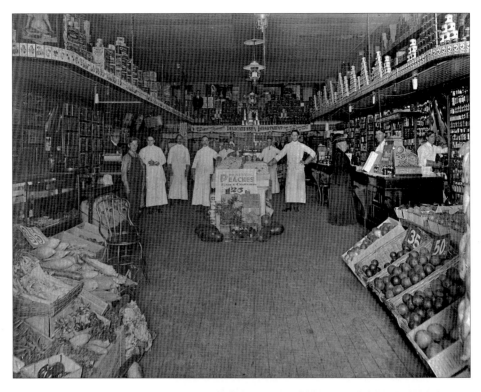

Above: *The Dixi H. Ross Company grocery store on Government Street, between Yates and Johnson streets, in 1911. The US-born Ross operated the store from 1890 to 1913.*

Right: *Victoria remained a hard drinking town long after the pioneer era, and most groceries sold liquor. British Columbia instituted both prohibition and women's suffrage in 1917. The BC government began operating liquor stores and licensing "beer parlours" in 1920, but Victorians elected to stay "dry" for decades.*

Opposite top: *Garden party at a Rockland Avenue home in July 1914 for the 50th Regiment, Gordon Highlanders and the Lady Douglas chapter of the Imperial Order of the Daughters of the Empire.*

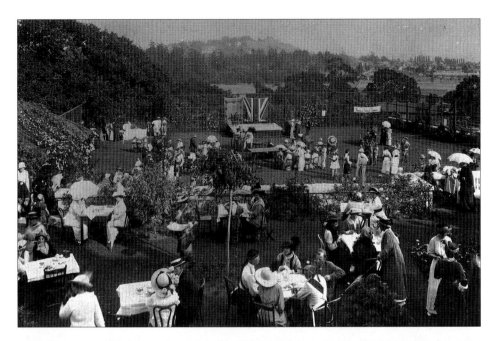

General Currie's Secret

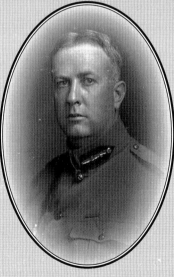

WHEN VOLUNTEERS with the 50th Regiment departed for camp in Valcartier, Quebec, in August 1914, Lieut.-Col. Arthur W. Currie (1875-1933) was its commander. Currie was soon asked to command the much larger 2nd Canadian Infantry Brigade, but the collapse of Victoria's economy had left the real estate agent and former school teacher in financial straits. Currie used nearly $11,000 of the 50th Regiment's uniform allowance to repay his personal debts.

Currie became Canada's most famous field commander in World War I. After serving in the trenches in the brutal second battle of Ypres, Currie was pro-moted to brigadier-general and appointed to command the Canadian Corps 1st Division. He studied the disastrous mistakes of the British command in the battle of the Somme (1916) and engineered the capture of Vimy Ridge in April 1917. Currie was knighted and made field commander of the Canadian Corps. Then his debt to the 50th Regiment surfaced. Currie quietly settled the account. His reputation for tactical brilliance at Passchendaele and other battles has endured.

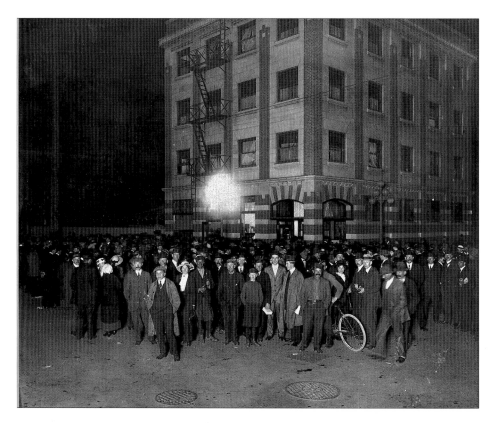

Above: *An angry mob gathered at the Kaiserhof Hotel, on the corner of Johnson and Blanshard streets, on May 8, 1915, after a German U-boat torpedoed the RMS* Lusitania, *near the coast of Ireland, causing 1200 civilian deaths. The Kaiserhof was owned by Baron Alvo von Alvensleben, who operated logging camps on Vancouver Island.*

The mob destroyed the German Club on Government Street, wrecked the Kaiserhof, and sacked businesses operated by Victorians with German names.

Among Victorians on the Lusitania *was James "Boy" Dunsmuir, 21, younger son of James and Laura Dunsmuir, who had volunteered to serve in an English cavalry regiment. The loss unhinged his father. He listened by the hour to a recording of* Where is My Wandering Boy Tonight *by the Irish-American tenor John McCormack.*

Among local families reported in the 1916 Canadian Annual Review *were five brothers in the Mathieson family, and "Arthur Green and three sons." In the*

George family, three sons had been killed, one was missing, one a prisoner, two at the Front, and "two waiting till they were old enough to go."

Over the winter of 1918-1919, a grim toll mounted: as many as 50,000 Canadians died of pneumonia and other infections caused by the Spanish flu. In Victoria, public meetings were banned in October and November 1918. Many public buildings closed. Fire halls and residences were turned into emergency hospitals.

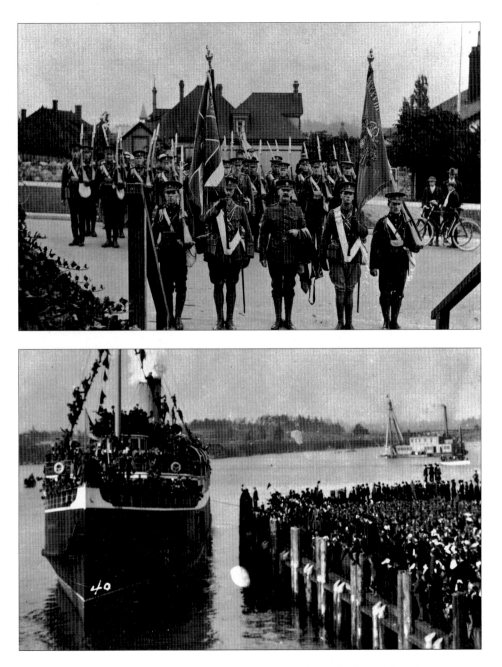

Above: *Colours presented to the 88th Regiment, Victoria Fusiliers.*

Below: *More than 1150 volunteers shipped out with the 30th Battalion on the Princess Mary on February 14, 1915.*

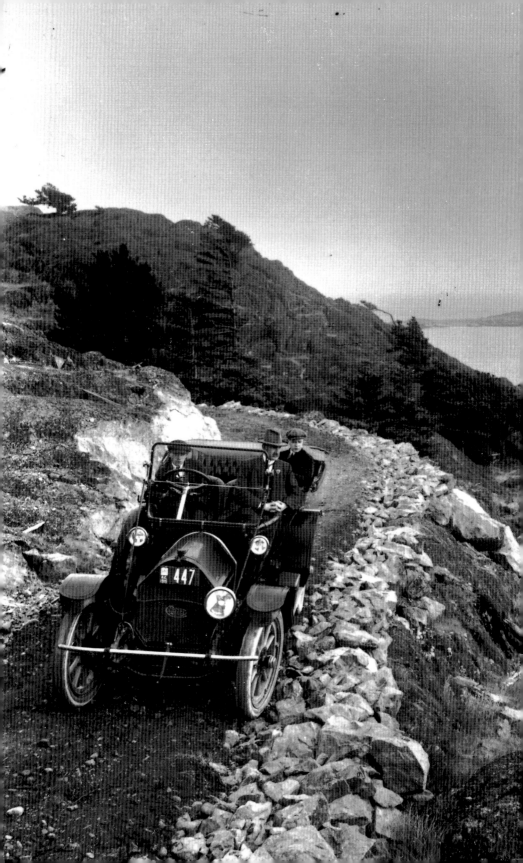

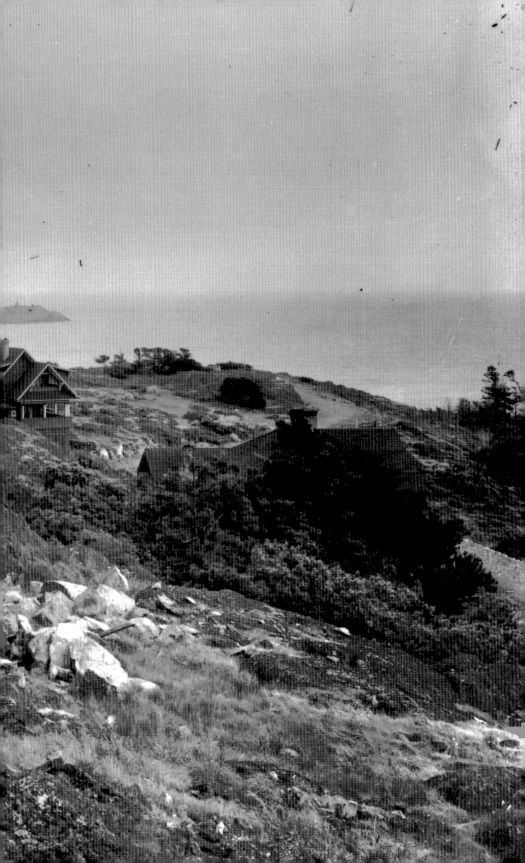

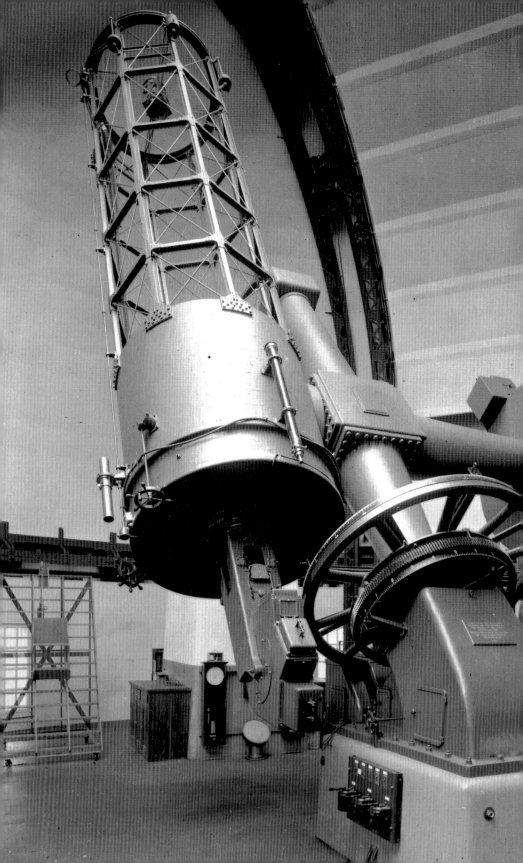

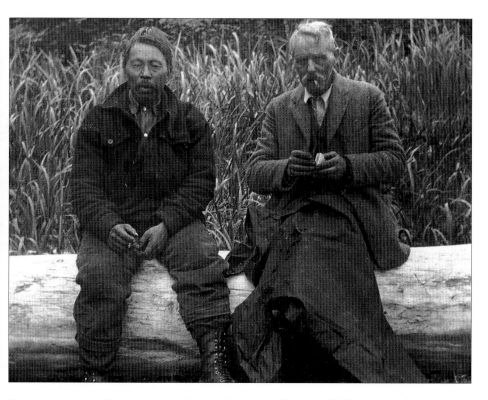

Previous page: *Motoring on Gonzales Hill, 1915.*

Opposite: *The Dominion Astrophysical Observatory was completed in 1918 on Little Saanich Mountain. The 1.83-metre mirror of the reflecting telescope was the largest in the world at the time. Astronomers with the federal government chose the site because of the atmospheric stability of the Victoria area.*

Above: *Charles Newcombe with Henry Moody, a Haida man, in the Queen Charlotte Islands in 1923.*

British Columbia's first psychiatrist, Newcombe (1851-1924) studied medicine in Scotland and lived in Oregon before moving to Victoria in 1885. A born collector as well as an excellent photographer, Newcombe became closely associated with the BC Provincial Museum. He was an early member of the Victoria Natural History Society, which laid the groundwork for the museum's biological collections. He mounted many anthropological expeditions up the West coast, often in his own hand made boat and accompanied by his son,

William.

Newcombe arranged the sale and export of many monumental carving. He worked as a field ethnologist with Chicago's Field Museum and, from 1911 to 1914, collected for the Provincial Museum, which assembled one of the most significant collections of Northwest Coast cultural artifacts anywhere. Dr. Newcombe was an early collector of Emily Carr's art. Willie Newcombe became one of Carr's closest allies and a trustee of her estate.

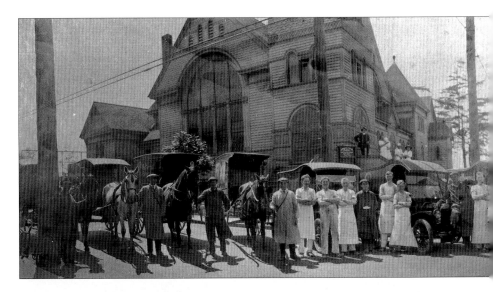

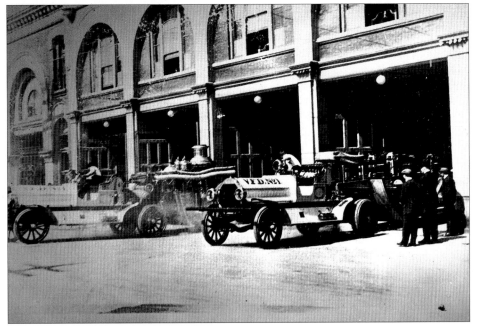

Above left and right: *Staff and vehicles of Rennie & Taylor's Bakery, Gladstone Avenue and Fernwood Road, about 1920. The Emmanuel Baptist Church is on the left, the bakery on the right. Fernwood became one of the city's liveliest residential neighbourhoods after a streetcar line was installed to a terminus at this corner in 1891. Today the corner looks much the same.*

Below: *Fire engines at the No. 1 Fire Hall on Cormorant Street, across from City Hall. From 1903 to 1913 the Victoria and Sidney Railway terminus shared the building with the Fire*

Hall. When the railway went out of business, the space was converted to a public market. The building was torn down in the 1960s to make way for Centennial Square.

Below: *The Sooke Stage and Freight Company, George Jones, proprietor, operated in the 1920s.*

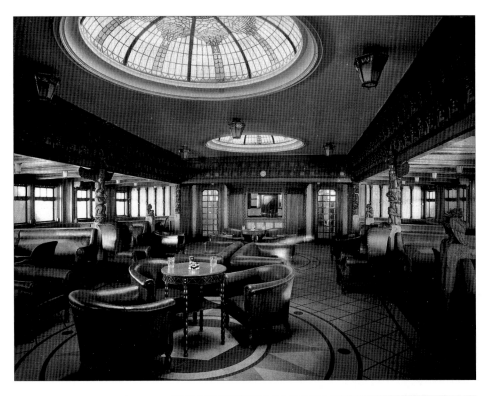

Above: *The smoking lounge of the SS* Princess Kathleen. *The luxurious 5330-tonne passenger ship and her twin sister* Princess Marguerite *were named for Marguerite Kathleen Shaughnessy, daughter of Thomas Shaughnessy, president of the CPR from 1899 to 1918. The two ships operated on the Triangle Route between Victoria, Vancouver and Seattle from 1925 to 1941.*

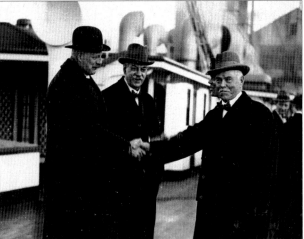

Below: *Captain James W. Troup, at right, taking delivery of* Princess Kathleen *at Clydebank, Scotland, January 15, 1925.*

Troup was manager of the CPR's Coast Steamship Service from 1901 to 1928. More than 30 ships bore the name Princess. The names of the bigger ships are local legends—Victoria, Charlotte, Adelaide, Alice, Louise, Kathleen, *the two* Patricias *and the two* Marguerites, Elizabeth *and* Joan. *They were increasing-*

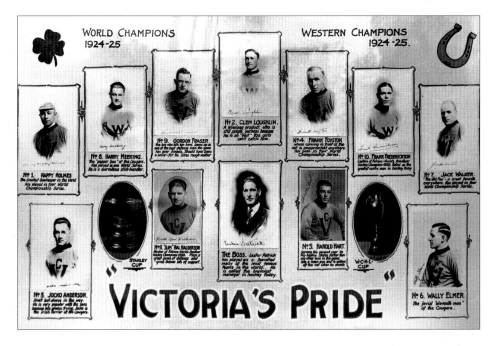

WORLD CHAMPIONS 1924-25

WESTERN CHAMPIONS 1924-25.

Nº 2, CLEM LOUGHLIN.

Nº 9, GORDON FRASER

Nº 8, HARRY MEEKING.

Nº 4, FRANK FOYSTON

Nº 10, FRANK FREDERICKSON

Nº 1, HAPPY HOLMES.

Nº 7, JACK WALKER

STANLEY CUP

Nº 11 "SLIM" HAL HALDERSON

THE BOSS, Lester Patrick

Nº 5, HAROLD HART.

W-C-H-L CUP

Nº 3, JOCKO ANDERSON.

VICTORIA'S PRIDE

Nº 6, WALLY ELMER

ly throwbacks to an earlier time, when the options for travel were fewer and the pace more leisurely.

Above: Canada's first artificial ice surface hosted the first professional hockey game played west of the Great Lakes. The date was January 3, 1912; the place, Oak Bay. The arena was built by Lester Patrick. He was the local team's owner and its coach and the captain. And he scored the first goal.

Lester Patrick (1883-1960) was one of the first rushing defencemen in hockey. He started in Brandon, Manitoba, and played with the Montreal Maroons in 1906. Patrick settled in Victoria in 1911. His family built arenas in Vancouver and New Westminster, as well as Victoria, and established the three-team Pacific Coast Hockey Association. Patrick's team solidified as the Victoria Cougars in 1918-19, and competed in a regrouped Western Canada Hockey League. The likes of Newsy Lalonde, Eddie Shore and Bill Cook played on prairie teams.

Under the Patricks' inspiration, Western Canada was a centre of innovation. The teams put numbers on players' jerseys (1911-12); established the centre zone in which forward passing was allowed, producing the fluid play so characteristic of the game (1913); started post-season playoff series (1918); and made line changes on the fly (1925).

The young National Hockey League was flourishing when the powerful 1924-25 Montreal Canadiens caught the train west for an unlikely Stanley Cup series. On the Canadiens' roster were a dazzling young forward named Howie Morenz and the legendary goalie Georges Vézina. The Victoria Cougars had squeaked into the playoffs. In the five-game series, three games were played by Patrick rules and two by eastern rules. The Cougars skated rings around the Canadiens and won the series three games to one.

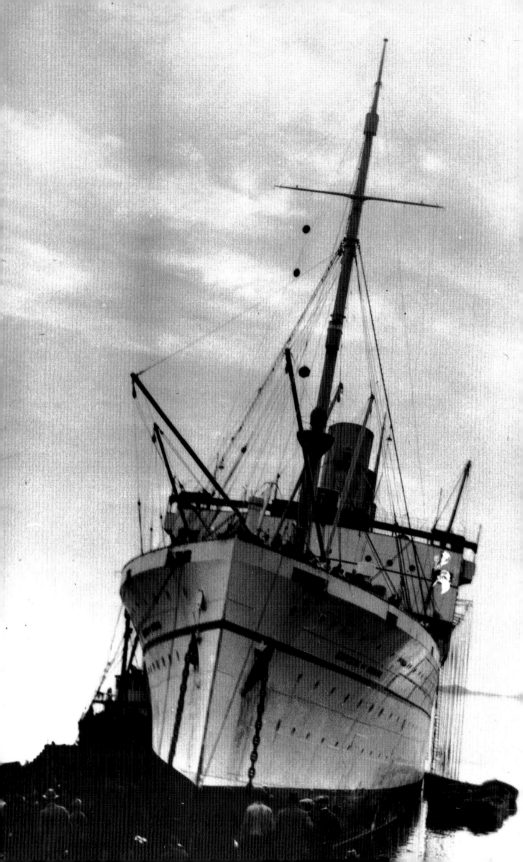

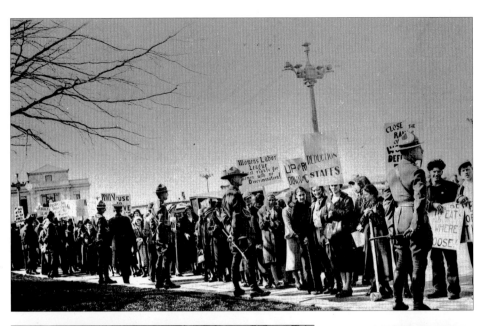

Opposite: *The SS Empress of Canada ran aground off Albert Head in a fog in 1929.*

Above: *Unemployed workers protest near the Parliament Buildings, 1933.*

Below left: *Simon Fraser*

Tolmie and Mrs. Tolmie. Tolmie (1867-1937) was born and died at Cloverdale, the family farm established by his father, William Fraser Tolmie, in 1860. Trained as a veterinary scientist, Tolmie was premier of BC from 1928 to 1933.

Below right: *Nellie L. McClung (1873-1951), women's suffrage leader, legislator, and author of 10 books, moved into a Gordon Head home, Lantern Lane, in 1935.*

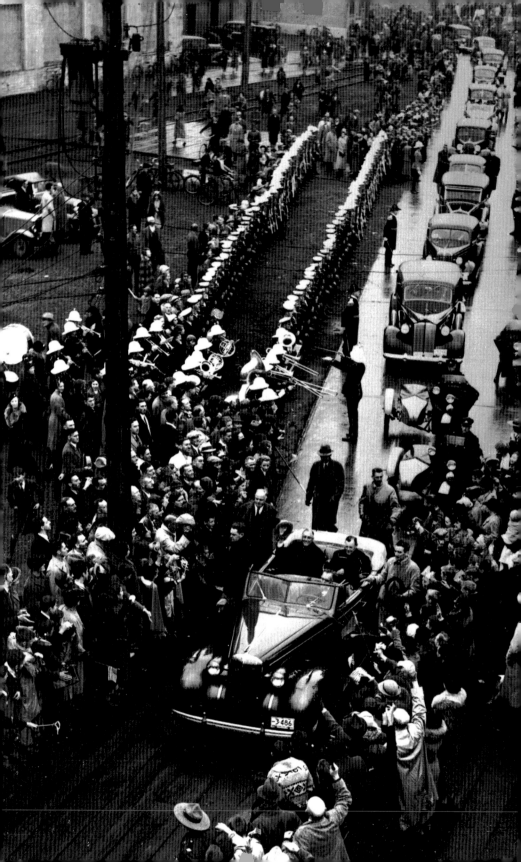

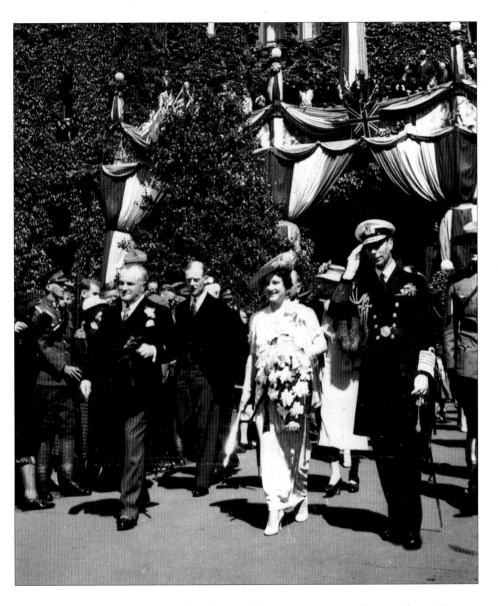

Opposite: *US President Franklin D. Roosevelt and Mrs. Roosevelt visited on September 30, 1937. During private talks with BC Premier Duff Patullo at Government House, Roosevelt broached the idea of building a highway from British Columbia to Alaska—a project undertaken in 1942.*

Above: *King George VI and Queen Elizabeth visit Victoria, May 29 to 31, 1939. The Royal couple sailed to Victoria on the* Princess Marguerite, *stayed two nights at Government House, and returned to Vancouver on the* Prince Robert. *At an Empress Hotel luncheon, King George made a speech that was broadcast around the Empire.*

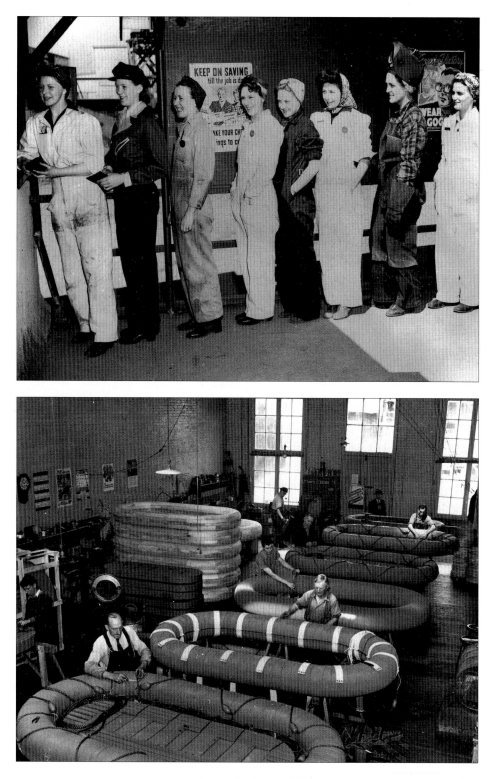

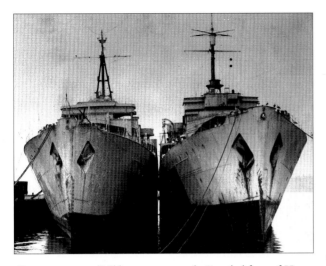

Opposite top: *Welders at the Victoria Machinery Depot, about 1943.*

Opposite bottom: *Life raft manufacturing in Victoria.*

Above: Prince David *and* Prince Robert *at Lynn Creek naval base, North Vancouver, in January 1946.*

Three speedy 6250-tonne passenger ships, built for the Canadian National Railway began service in 1930. The Prince Robert survived on the up-coast run; the others were transferred, chartered, laid-up, or sold.

Then came World War II. The Princes, designed for wartime conversion, were pressed into duty. HMCS Prince David and Prince Henry patrolled Atlantic waters, while Prince Robert escorted ships carrying Canadian Army troops to bol-

ster the British defence of Hong Kong. Returning, Prince Robert left Pearl Harbour on December 6, 1941, hours before the Japanese attack that launched the war in the Pacific. Prince David and Prince Henry soon joined her in Esquimalt for coastal patrol duty.

In the summer of 1942, Columbia Pictures descended on Victoria to shoot a film, The Commandos Strike at Dawn, celebrating the success of British raids on the European coast. Fjord-like Saanich Inlet was transformed into Norway, complete with an occupied fishing village. Prince David was decked out as a Royal Navy cruiser, and her commander had a bit part. The Royal Rifles of Canada, Sault Ste. Marie and Sudbury regiments, and the Canadian Scottish played the commandos, with the 114th Veteran's

Guard as the Nazi garrison. One morning, actor Alexander Ross terrified the denizens of the Empress Hotel when he strode through the lobby in his Nazi commandant's uniform, trailed by Wermacht troops, having missed the company bus to the shoot.

The three Princes steamed off to Alaska to participate in the Aleutian anti-sub campaign. Later, Prince Robert's firepower was beefed up for anti-aircraft duty in the Bay of Biscay, while Prince Henry and Prince David were converted to infantry landing ships. On June 6, 1944, they participated in the Normandy invasion as first-wave assault carriers. Aboard was the same Canadian Scottish Regiment that had play-acted war in Saanich Inlet two summers before. Prince David went on to transport British commandos to raids on the Greek coast. She carried the Greek government, returning from exile, to a tumultuous welcome in Piraeus.

By March 1945, two of the ships were back in Esquimalt for the endgame in the war against Japan. Prince Robert returned to Hong Kong bearing the troops who greeted the emaciated prison-camp inmates, including survivors of the Canadian forces the ship had escorted there in 1941.

Modern Victoria

Victoria's character has continued to change dramatically since World War II. The transformation is really an exaggeration of previous trends. Most noticeably, the city's traditional industrial base has all but disappeared, as the rapidly changing technology of commercial transportation rendered Victoria's island setting inhospitable to manufacturing. The sawmills, flour mill, shingle factory and paint factory, all the manufacturing concerns that ringed the waterfront for a century—even the shipyards—are gone. The city's function as a port has withered away, and the downtown core, where a century ago the wholesale merchants and shipping companies vibrated with the commerce of the province, has become a kind of architectural museum.

Other industries have come to the fore. Government payrolls grew by leaps and bounds. Many of the holes in Victoria's urban landscape have been filled by government office buildings. Tourism has all but taken over the Inner Harbour. The city now caters to more than three million visitors annually. Outdoor recreation is a boom industry. The retirement industry has mushroomed. Service industries now employ 85 percent of the Victoria area's labour force.

W.A.C. Bennett, Social Credit Premier of British Columbia from 1952 to 1972, ruled the province like his personal fiefdom from the Parliament Buildings in Victoria. His party's program of industrial expansion and infrastructure development had a profound effect on the capital city.

Bennett created the BC Ferry Corporation to link Vancouver Island with the world. Before the efficient end-loading ferries began running in 1960, a few hundred cars and trucks entered Vancouver Island every day. The changes are everywhere evident. Once-tiny ribbons of pavement that snaked into town from the hinterland are now highways choked with vehicles. On the Saanich Peninsula and in the Western Communities, where until 40 years ago farming all but sustained the city's population, bottomland and hillside are rapidly being converted to suburban housing and shopping malls. The area's population has doubled and doubled again.

With the coming of the large ferries, Victoria lost its splendid isolation and joined the modern world.

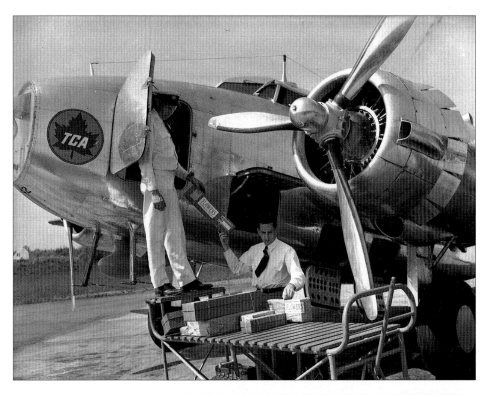

Above: *Shipping daffodils by air, Patricia Bay Airport, 1947. Commercial cultivators supplied Easter colour to parts of the continent still covered in snow.*

Right: *Looking north from Mount Tolmie, 1944. Gordon Head district was still largely berry farms, dotted with water towers that were used for irrigation in times of drought. Gordon Head was famous for strawberries, beginning about 1920. Only a few greenhouses, one converted water tower, and the odd barracks remain.*

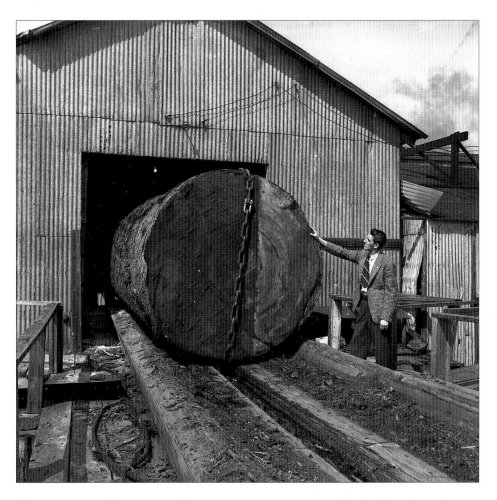

Opposite top: *Nylon hosiery factory, Victoria, 1953. Manufacturing declined sharply after World War II.*

Opposite bottom: *Digging and sacking potatoes, Saanich, 1947. Much of the Saanich Peninsula's arable land has since been lost through development.*

Above: *A Douglas fir log enters the mill of Sweeney*

Cooperage, 1946.

Mike Sweeney, a hand cooper from Newfoundland, settled in Victoria in 1889 with his family, including six sons, and set up a cooperage on Fort Street. A staff of five turned out 30 barrels a day, supplying winemakers, grocers, even sealskin wholesalers. At first, the company used the traditional barrelwood, oak, but the Sweeney family introduced the use of edge-grain

Douglas fir. After moving twice, the company built a cooperage on Lime Bay, in Victoria West, in 1923. By 1938, the factory produced 1000 barrels a day, which it sold to 16 countries. Then the bottom fell out of the barrel business. The plant closed in 1948, and the company moved to Vancouver.

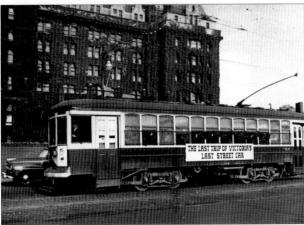

accusations of bribery. Forests minister Robert Sommers had, in fact, accepted what he called loans. After lengthy investigation, government stonewalling, and prosecution, Sommers was sentenced to five years in prison—a first for a minister of a Commonwealth government.

Opposite: *The BC Electric service garage opened on Douglas Street in October 1948.*

Above: *Logger Gordon Gibson, was elected MLA in* 1953 *and took aim at the practice of awarding exclusive rights to large areas of BC forest. When a large Vancouver Island licence was granted to BC Forest Products Ltd., Gibson made vague*

Below: *The last streetcar makes its final trip, July 5, 1948. "There was a homeliness and familiarity about them that had its own attraction," a* Times *editorial stated, "a dowdy dignity that the streamlined buses cannot match."*

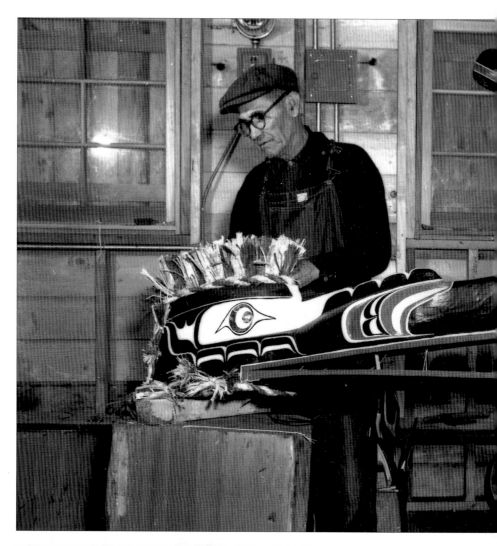

Left: *Mungo Martin painting one of the rear house posts for his replica of the Fort Rupert chief's house in Thunderbird Park.*

Opposite bottom: *Dance of the Animals at the potlatch ceremony in Mungo Martin's house, 1953.*

Left: *Mungo Martin (ca. 1881-1962) was almost singularly responsible for the revival of Northwest Coast Indian art, for he brought it to wide public attention during the last two decades of his life. A commercial fisherman from Fort Rupert, on northeastern Vancouver Island, Martin came to Victoria in 1952 to be chief carver for the BC Provincial Museum's totem pole restoration program.*

He was also an important chief of the Fort Rupert Kwakiutl people. One of eight prestigious names that he inherited was Naqapekim ("ten times a chief"), acquired from a 19th-century chief.

He built a house in Thunderbird Park, a half-size copy of that chief's. The ceremony Martin staged to mark the completion of the house was in the Kwakiutl tradition of potlatch, or gifting. The potlatch was outlawed in 1884 by Canadian law but continued surreptitiously until the statute was repealed in 1951.

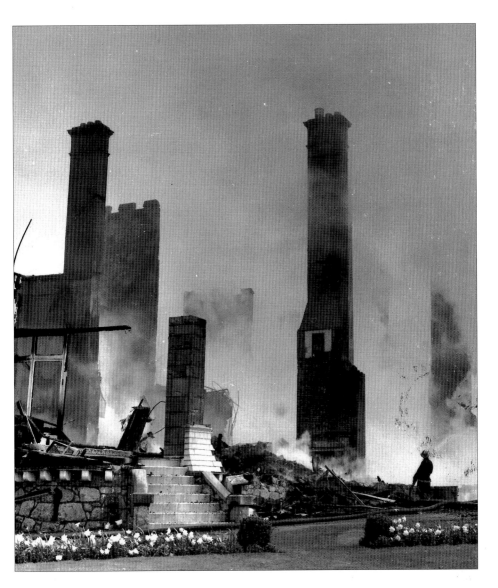

Opposite top: *Princess Elizabeth and her husband Prince Philip during their visit to Victoria in October 1951.*

Opposite bottom: *Christmas ball at Government House in the 1950s.*

Above: *Government House after the fire of April 15, 1957. The wood-frame turn-of-the-century mansion was poorly wired and inadequately fireproofed. The lieutenant-governor and chatelaine were forced to flee in their nightclothes and could not rescue even a pet bird. They took up residence at the Empress Hotel until the third Government House was completed in May 1959. The only salvageable structure was the stone porte cochère, built in 1909. It was incorporated into the new vice-regal mansion.*

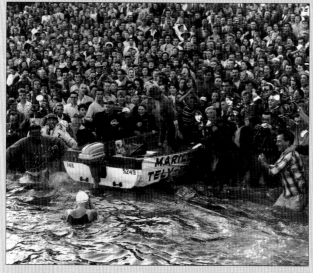

IT'S NOT RECORDED whether anyone tried swimming the daunting 29 kilometres across the Strait of Juan de Fuca before the Victoria *Daily Times* cooked up a scheme to promote the city and offered a $10,000 prize to the conqueror. When *Times* publisher Stuart Keate lured Olympic swimmer Florence Chadwick from California in 1954, the stunt provoked a craze.

If anyone could swim the strait, Chadwick should have. A sort of professional strait-swimmer, she had swum across the Strait of Gibralter, the Bosporus, the Dardanelles, San Pedro Channel (from Los Angeles to Santa Catalina Island), and the English Channel—three times. Gamely she set out from Oak Bay, heading for Port Angeles on an ebbing tide. She didn't get far. The roiling tides and frigid water stumped her. She was paid anyway, out of good sportsmanship, or perhaps pity.

More than 50 other people with greater ambition than stamina or sense also tried swimming the straits and failed. The following summer, Bert Thomas, a logger from Tacoma, Washington, succeeded on his fifth try, landing in Esquimalt. (There are those who suspect he faked it because his arrival was unheralded.)

In 1956, Canadians Cliff Lumsden and Marilyn Bell both made the crossing. Bell, a native of Toronto, swam across Lake Ontario at age 16 (1954), and the English Channel at 17. Starting from Victoria, Bell struggled to within eight kilometres of the Port Angeles shore before being pulled unconscious from the water. But she gamely tried again. This time, she started from the US side and completed the crossing. She was greeted by a crowd of more than 30,000 at a beach near Beacon Hill Park.

After Juan de Fuca, Marilyn Bell gave up distance swimming, saying there was no greater goal for her to pursue. She went on to become a school teacher in New Jersey. A cairn near the Dallas Road cliffs, east of Finlayson Point, commemorates her achievement. Few people have been courageous—or crazy—enough to try to swim the strait since.

In 1884, the Esquimalt Water Works Company obtained water rights to Goldstream River and began piping the water. In 1897, the water company began supplying much of Victoria's power until the larger Jordan River power station was completed in 1911. It continued to operate until 1957. Eventually, the city obtained access to Goldstream by expropriating Esquimalt Water Works. In 1948, the core Victoria municipalities created the Greater Victoria Water District. The water district donated 355 hectares near the mouth of the river to the province in 1957 for Goldstream Park.

Below: *Sport fishers display the salmon catch at Brentwood Bay, 1947.*

Above: *Campers at Goldstream Park, 1950.*

The Goldstream area was an early Victoria outdoor recreation centre. The original Goldstream Hotel was a favorite destination for picnickers.

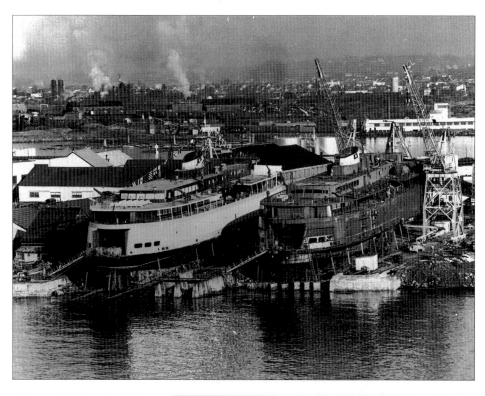

Above: *The launch of the MV* Queen of Saanich *at Victoria Machinery Depot's Ogden Point shipyard, November 28, 1962; the* Queen of Esquimalt *under construction nearby.*

Right: *Rev. P. A. ("Flyin' Phil") Gaglardi, BC's minister of highways from 1955 to 1968, was responsible for construction of "more highways than anyone else in the world" and of the BC ferry system's initial fleet and terminals. A Pentecostal minister in Kamloops, Gaglardi acquired a long record as a speeder and had his driver's* licence suspended more than once. He was stripped of the highways portfolio in 1968, following allegations his family was profiting from highways contracts and benefiting from ministry work-orders. Gaglardi's daughter-in-law was discovered to have used a government jet to

fly to Texas.

Above : The Inner Harbour during Swiftsure weekend, 1965. Sailboats from all over the Pacific coast congregated in Victoria's Inner Harbour on a Friday evening at the end of May each year, starting in 1951. By the mid-1960s, the Swiftsure Lightship Classic was one of the most exhilarating of yachting races. Dozens of million-dollar boats competed in the premier event, challenging the briniest and brainiest of mariners—a 252-kilometre loop around a marker at the opening of the Strait of Juan de Fuca and back to Victoria. Every Swiftsure weekend, a festive atmosphere took hold of the city. The crowded Inner Harbour causeway reverberated with the firing of field guns and the skirl of the Sea Cadet band's bagpipes at the Sunset Ceremony on the lawn of the Parliament Buildings.

Swiftsure became the overture to a much longer yachting fixture, the Victoria-to-Maui race, in the 1960s. By the early 1970s, Swiftsure was a monster event. Nearly 200 vessels crammed into the harbour in 1971. In 1980, more than 400 boats competed in six races. As a new generation of light-displacement vessel became popular, Swiftsure became a handicapper's nightmare. The handsome old wooden yachts were gradually displaced. Swiftsure has since lost much of its character and prestige.

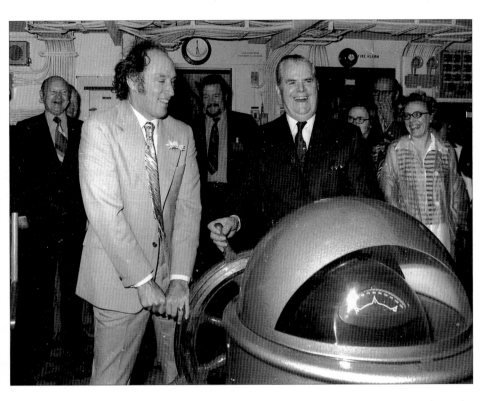

Above: *Prime Minister Pierre Elliot Trudeau and BC Premier W.A.C. Bennett aboard the* Queen of Esquimalt *during the 1971 First Ministers' Conference in Victoria. According to a newspaper report, "Trudeau took the wheel and asked Bennett to join him, suggesting they steer in opposite directions."*

Opposite top: *Bastion Square before restoration.*

Opposite bottom: *Bastion Square in 1965, after restoration.*

Victoria's downtown might have taken a dramatically different turn. The 1878 City Hall was under threat of demolition in the late 1950s. Thanks to energetic city planner Roderick Clack and the sizeable legacy of Thomas Shanks McPherson, a compromise plan preserved City Hall and the old Pantages Theatre and integrated them into the city's first redevelopment project, the spacious Centennial Square. Within a few years Bastion Square was fashioned out of a hole in the run-down warehouse district, and the former Provincial Court House became the Maritime Museum of British Columbia. In the 1970s, developer Sam Bawlf's imaginative Market Square development signalled the start of a restored Old Town commercial district, and a rejuvenated Chinatown soon followed, under the impetus of geography professor David Lai.

PHOTO CREDITS

British Columbia Sports Hall of Fame and Museum
89

City of Victoria Archives
44 (M07830), 51 (M06611), 62/63 (M00018/M00019), 65 top (M06999), 72/73 (M05843), 76 (M06762), 77 bottom (M06775), 86/87 (M00652/M00653), 110 top (M08454), 110 bottom (M08026)

Royal BC Museum, BC Archives (Historical photos, HP, unless otherwise specified)
1 (2657), 2 (18267), 5 (93669), 7 top (PDP239), 7 bottom (24511), 8 top (PN 6810), 8 bottom (PN 6838), 9 (94485), 10/11 (95510), 10 (3056), 11 (4326), 12 top (11360), 12 bottom (1906), 13 top (53094), 13 bottom (29989), 14 (2627), 15 top (12178), 15 bottom (1996), 16/17 (PDP1538), 16 (1190), 19 top (8735), 19 bottom (8202), 20/21 (1539), 20 (54032), 21 (18256), 22 left (33188a), 22 right (37775), 23 top (8720), 23 bottom (21198), 24/25 (7873), 26 (56736), 27 (93235), 28 (94591), 29 top (93187), 29 bottom (93681), 30 top (49835), 30 bottom (99263), 31 top (PDP627), 31 bottom (27429), 32/33 (PDP223), 34 top (22364), 34 bottom (93157), 35 top (22019), 35 bottom (4578), 36 (9447), 36/37 (9442), 38 (66075), 39 top (68212), 39 bottom (50119), 40/41 (52058), 42 (8242), 43 (68226), 45 (25026), 46 (8746), 47 (11838), 48/49 (80799), 49 (27716), 50 (65295), 50/51 (203), 52 (436), 53 top (28730), 53 bottom (42297), 54/55 (67689), 54 (8912), 55 (8911), 56 (57245), 57 top (35359), 57 bottom (19272), 58/59 (11926), 60 (11581), 61 (22548), 63 (6928), 65 bottom (77584), 66 top (63487), 66 bottom (32864), 67 top (51933), 67 bottom (37573), 68 (63896), 69 top (55320), 69 bottom (97505), 70 (99186), 70/71 (39943), 74 top (77581), 74 bottom (22066), 75 (94036), 77 top (68913), 78 top (93781), 78 bottom (93782), 79 top (8336), 79 bottom (43915), 80 (7994), 81 top (35689), 81 bottom (35688), 82/83 (12982), 84 (49935), 85 (56998), 86 (80730), 87 (57789), 88 top (16910), 88 bottom (56134), 90 (51370), 91 top (70521), 91 bottom left (61716), 91 bottom right (75432), 92 (1767), 93 (42572), 94 top (95128), 94 bottom (74094), 95 (79555), 97 top (B03-A0626), 97 bottom (B03-A005), 98 top (B03-A0588), 98 bottom (B03-A0373), 99 (B03-A0580), 100 (94596), 101 top (96849), 101 bottom (23922), 102 (B03-A0475), 102/103 (99436), 103 (B03-A0481), 104 top (30783), 104 bottom (43511), 105 (43342), 106 (Ryan Collection, H-5992), 107 top (B03-A0416), 107 bottom (B03-A0453), 108 top (46053), 108 bottom (96845), 109 (B03-A0429), 111 (95982)

PETER GRANT has written for periodicals such as *Beautiful British Columbia*, *Western Living*, and the *Vancouver Sun*. He lives in Victoria with his wife and daughter.

Acknowledgements
The author acknowledges the permission of Stoddart Publishing Ltd., Don Mills, Ontario, to quote from the works of Emily Carr: *The Book of Small* (Toronto: Irwin Publishing Inc., 1942) and *Growing Pains: An Autobiography* (Toronto: Irwin Publishing Inc., 1946). The Estate of George Woodcock gave permission to quote from *Amor De Cosmos: Journalist and Reformer* by George Woodcock (Toronto: Oxford University Press, 1975).